W9-BBO-869

WITHDRAWN
No longer the property of the
Boston Public Library.
Sale of this material benefits the Library.

Bemelmans

THE LIFE & ART OF MADELINE'S CREATOR

BY JOHN BEMELMANS MARCIANO

Viking

For Mom

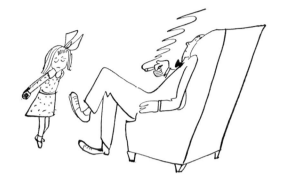

VIKING
Published by the Penguin Group
Penguin Putnam Books for Young Readers, 345 Hudson Street, New York, New York 10014, U.S.A.

Penguin Books Ltd, Registered Offices: Harmondsworth, Middlesex, England

First published in 1999 by Viking, a division of Penguin Putnam Books for Young Readers.

1 3 5 7 9 10 8 6 4 2

Copyright © John Bemelmans Marciano, 1999
All rights reserved

LIBRARY OF CONGRESS CATALOGING-IN-PUBLICATION DATA
Marciano, John.
Bemelmans : the life & art of Madeline's creator / by John Bemelmans Marciano.
p. cm.
Includes index.
ISBN 0-670-88460-X
1. Bemelmans, Ludwig, 1898–1962—Characters—Madeline.
2. Children's stories, American—History and criticism. 3. Authors,
American—20th century Biography. 4. Illustrators—United States
Biography. 5. Madeline (Fictitious character)
6. Bemelmans, Ludwig, 1898–1962. I. Title.
PS3503.E475Z78 1999 818'.5209—dc21 [B] 99-25646 CIP

Book design by Edward Miller
Printed in China • Set in Perpetua

WR BR
J
PS3503
.E475
Z78
1999

Care has been taken to trace the ownership of the selections included in this work and to make full acknowledgment
for their use. If errors or omissions have occurred, they will be corrected in subsequent editions, provided
written notification is made to the publisher.

Contents

Author's Note

page vi

Author's Note

The painting above hung over my bed while I was growing up as a child. It is from *Madeline in London* and was given to my mother by her father, Ludwig Bemelmans. He died before I was born, but his presence was in our house, not only on the walls but in the tales my mother and grandmother would tell. And then of course at bedtime were his books.

A children's book combines two elements: writing and art. What makes my grandfather unique is his range and accomplishment in each of these fields beyond the realm of children's literature. He was a prolific writer of novels, short stories, humorous articles, and even a movie. He drew comic strips, illustrated articles, and painted dozens of covers for the *New Yorker* and *Town & Country*. When he shifted his focus to oil painting, he met with great success there, too.

No conventional biography could capture what my grandfather was as a writer and artist. Only his own work can do that. So I have gone through all of it, over forty published books and hundreds of magazine pieces, and put into this book what I feel best represents the many different facets of his creative life.

And then there are the giant metal flat files in my grandmother's house. They contain paintings, sketches, unpublished writings, photographs, and more, most of which have gone untouched and unseen for the last thirty-five years. Choosing what of all this to include was the most exciting part for me, because it felt like a secret I was getting to share.

I have tried to place all this material in context, to show how Bemelmans' life and work were intertwined. What I have written is based on my grandfather's autobiographical fiction, tempered by his own notes, letters, journals, and unpublished articles, as well as legal documents, the recollections of my mother and grandmother, and my own common sense. Ultimately, I feel that I've gotten to know the grandfather I never met, and have been able to present a relatively accurate, coherent picture of his life, albeit one with obvious and unapologetic bias.

There is one thing I would like to add. In looking over my manuscript, my mother expressed her fear that it made her father seem too serious. Her memories revolve around how much fun he was. She remembers restaurant tables filled with celebrities of the arts and society, all held spellbound by her father's stories, swept up in the fun of being around him. She remembers how he would rest his head against his glass, and the smell of his cigar smoke. That he worked in the mornings. That he would drive her mother to Columbia University to go to class, and then walk his dog in the park. He liked to see matinees. He was insatiably restless.

So there it is, some of it anyway.

—John Bemelmans Marciano
New York, 1999

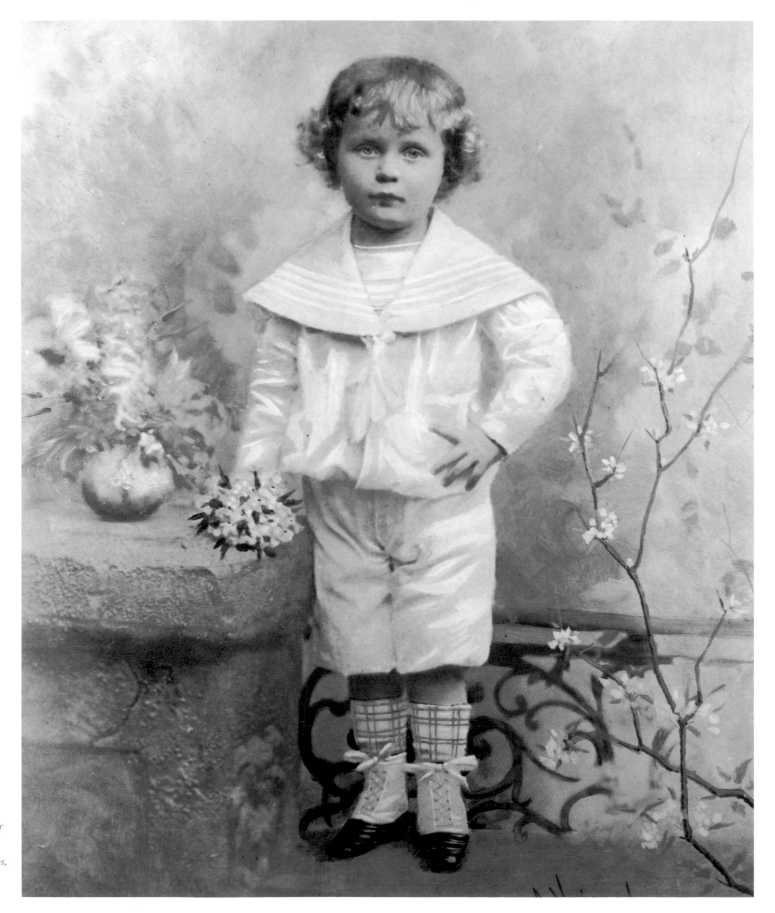

Portrait of Ludwig Bemelmans, age 3.

Part 1
1898-1939

"Like the pages of a children's book, the days were turned and looked at."

—*From "Swan Country,"* My Life in Art

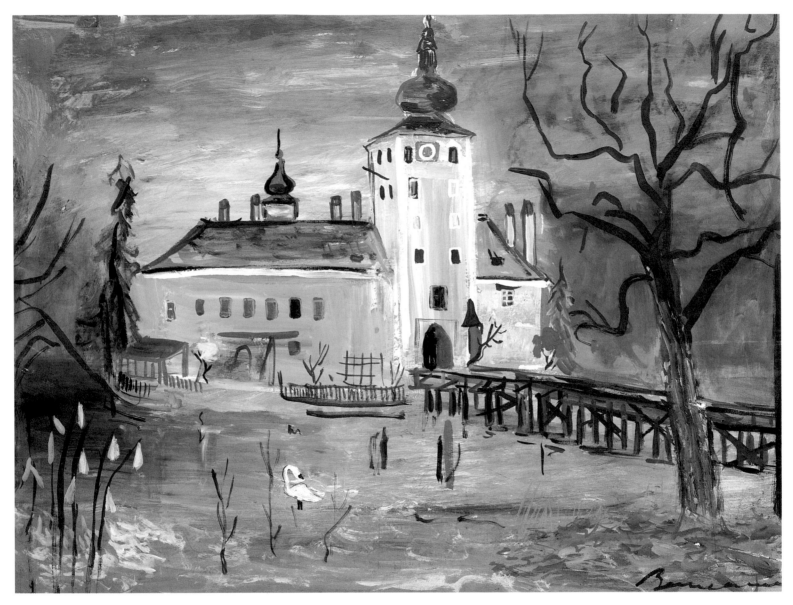

Schloss Ort, Gmunden, Austria. *Gouche, 1955.*

Bemelmans

As an adult,
Bemelmans would
return to Gmunden
to paint the scenery
of his childhood
(left). He would
also draw from
memory, as
in this picture of
him as a young
boy seated with
his governess
(above).

Ludwig enjoyed an idyllic early childhood in the mountains of the Austrian Tirol, in a town called Gmunden, where his father Lampert ran a hotel. He barely knew his parents—young Ludwig's sanctuary was the garden, where his constant companion was his young and beautiful French governess, whom he called Gazelle, because he could not pronounce *Mademoiselle*.

This life ended suddenly. When Ludwig was six, Lampert ran away with Emmy, the woman who would become his second wife; like him she left behind a spouse and young child. Gazelle, who was pregnant with Lampert's child, committed suicide. Ludwig and his mother, also pregnant, left for Regensburg, Germany, the home of her family, in a journey that Bemelmans later described:

> *I found myself in the arms of a strange woman, my mother, who was twenty-four years old then and very beautiful. She held me close and wept almost the entire journey from Gmunden to Regensburg.*

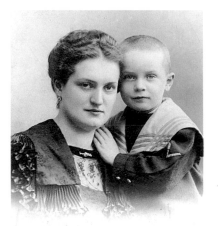

Ludwig with his mother, Franciska, in Regensburg.

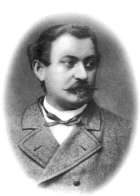

We arrived with a night train. My mother was expecting a child. The arrival was so planned that no one would see. A closed coach took us to the Arnulfsplatz. My grandfather wept and repeated, "Armes Weiberl, armes Weiberl," meaning "poor little woman, poor little woman." My grandmother held me in her arms and looked stone-faced, for she had made the path even and promoted the match. It was also said that among her many lovers had been my father.

For a long time, my mother locked herself into her rooms and never went out. That was because she was the first divorced woman in Regensburg. Except for the scandal with King Ludwig I and Lola Montez, no one had ever heard of a case like this. People were married—men had illegal children with servant girls and provided for them, and all that was accepted, but marriage was a sacred institution. They did not bother to ask who was the guilty party. The woman was marked. My grandfather, who had been very much against the marriage, insisted on the divorce.

Ludwig and Franciska Fischer, his maternal grandparents.

In the beginning Mama tried to replace Gazelle; mostly in tears, she dressed me and undressed me. There were no children's books, and she would tell me stories about her own childhood—of how alone she had been as a little girl and how she was shipped off to a convent school in Altötting, which was run by the kind nuns of an order known as the "Englische Fraülein." She described the life there—how the girls slept in little beds that stood in two rows and how they went walking in two straight lines, all dressed alike. She was much happier there than at home, for her parents had never had any time for her. This made me very sad. She cried, and I cried. She lifted me up; I looked at her closely, and a dreadful fear came over me. I saw how beautiful she was, and I thought how terrible it would be if ever she got old and ugly.

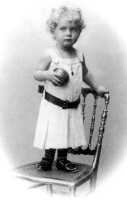

Ludwig, age 2.

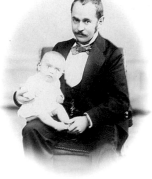

On his father Lampert's lap.

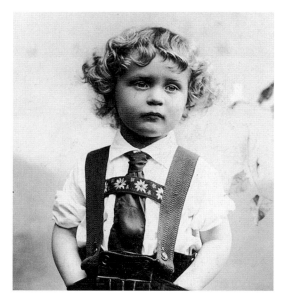

Besides bearing the weight of being a child of divorce—worse even than being a bastard child—Ludwig arrived in Regensburg speaking only French and dressing in the outlandish costumes that his father had provided. "The golden curls came off my head, I was shorn and put into new clothes, high-laced shoes with hobnails." Although his mother wanted him in a private school, he was placed in a public one, as his grandfather insisted on making a solid German citizen out of him. Here he stood out even more, but banded together with similarly outcast boys, who protected one another from "the potato heads," as Ludwig called his fellow pupils.

He failed the same grade repeatedly and was sent off to a boarding school in Rothenburg, which passed "even the dullest of students." Ludwig was deemed hopeless and dismissed. All this caused his mother great pain.

Ludwig, age 3 (top left); Ludwig and his parents on a family outing in Gmunden (bottom left).

Bemelmans would later write:

She had become hard and was determined to erase all traces of the past from me. But when they said—look he walks exactly like his father—then I would whip along on my toes and walk more so. I was determined not to yield. Part of German discipline is also, that after being punished one must ask for forgiveness and that I could not do. I said to myself that they can kill me, but I won't give in. I will not change, never never never. This enraged especially my mother who felt it her duty that in me she had to undo the wrong she had done to Opapa, herself and me. This went on for years.

Out of all other options for her willfully disobedient child, Ludwig's mother chose to send him back to Tirol to learn the hotel business from his Uncle Hans Bemelmans and Aunt Marie. But Ludwig showed little promise in the family business, and after being tried out at all of his uncle's hotels, he was presented with two choices. He could go to either a correctional institution or America.

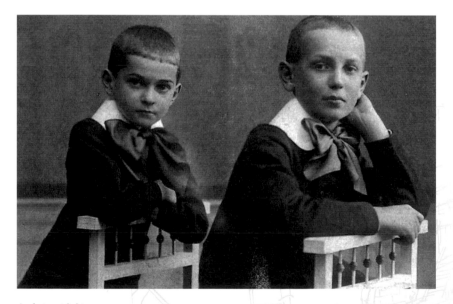

Ludwig with his younger brother, Oscar.

Lausbub

Bemelmans began many of his adult books with reminiscences of his childhood, as with "Lausbub," the first chapter of *Life Class* (1939), a book about his early years in America.

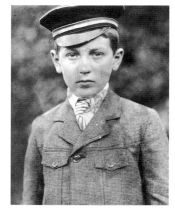

Ludwig in his boarding school uniform, shortly before going to live with his uncle and aunt.

From the very beginning Uncle Hans called me "Lausbub." Lausbub literally should mean "lousy boy," but in South Germany and Austria it is almost a tender word and means something like "rascal."

He always quoted America, telling me often that in America Lausbuben like me sometimes turned out to be very rich men. But in Tirol too, he said, there was bigger opportunity for a Lausbub than for a good boy who did as he was told and would perhaps make a good employee but never be rich.

Here in the hotel I found evidence of a lighter kind of life: the cooking was French, without kraut and heavy dumplings; the conversation had more variety, was not so much of buildings, horses, the Bartels, beer, and the pot de chambre *humor of Regensburg. I was disturbed by a sense of disloyalty to my Grandfather, because I felt I should not like anything else but his house and his person.*

I had brought some drawings and watercolors and given them to Aunt Marie. When Uncle Hans saw them and heard Aunt Marie suggest that I study painting, he got very angry. Painters, he said, were hunger candidates, nothing in front and nothing in back of them; besides, if I liked painting, I could always hire an artist, when I became rich by following his teachings. He said I must bury the past and start a new life and be a joy and pride to my poor mother and for God's sake not to become an artist like my father.

Aunt Marie would come into the little office when the lectures lasted too long, and say: "I think that's enough for today, Hans, let him go."

My birthday came soon after my arrival, and Aunt Marie bought me a box of the best watercolors and a drawing pad. I had a week of wonderful vacation and was given a horse on which I rode all over the beautiful mountains. Then one day it was decided that from eight in the morning until three in the afternoon I would be an employee and

do all the work that was required of me, and for the rest of the time, before and after, and during the night, I would be Uncle's nephew and eat at the family table, and could have the horse.

The mornings in Tirol are the most beautiful time in all the world. I got up at five, saddled my horse, and rode to the sawmill. It stood on a turbulent brook, flanked by high, straight walls of dolomite granite, among tall trees. Near by, under the two tallest and oldest trees, stood a little inn, with a garden, a curved wooden bench, and two round red-stone tables. There I stopped at seven every morning and drank a pint of red wine, dipping the hard peasant bread in it. I stayed as long as I could and then rode in a gallop back to the hotel to be on time for duty.

The first time I did this, Aunt Marie was up, and Uncle Hans out on his morning walk. He had said:"At least he gets up early, the Lausbub; that's something; some of them you can't get out of bed."Aunt Marie always looked at me and felt my head and said it must be the change in altitude."He has a fever every morning, and look how his eyes shine."But then they found out about the wine and several other things, and Uncle said that this half-nephew, half-employee arrangement was at an end. He said it would be better to send me to one of the other hotels where Aunt Marie could not help me out of every scrape.

And so I was sent first to the Mountain Castle in Meran, and then in the space of a year I ran through all of Uncle Hans's hotels. Every manager was tried out on me; they all failed and sent me back. The last time was after a very serious offense. Uncle walked up and down again; Aunt Marie cried and said to me while Uncle was with his ice machine:"Ludwig, Ludwig, what is going to become of you?"

When Uncle Hans came back he said there were two places for me to choose between. The first was a correctional institution, a kind of reform school, German, on board a ship, where unruly boys were trained for the merchant marine and disciplined with the ends of ropes soaked in tar.

The second was America.

I decided to go to America.

Uncle Hans Bemelmans.

Self-portrait as a busboy in Tirol, from a letter to his mother in 1913.

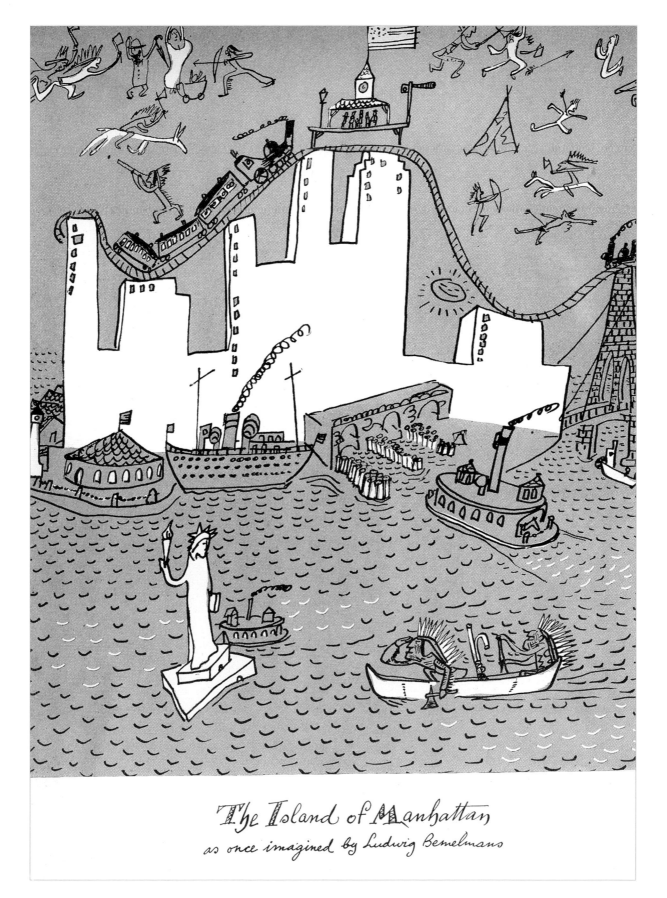

The Island of Manhattan

as once imagined by Ludwig Bemelmans

"The quality of my mind and its information at that time was such that, on sailing for America, I bought two pistols and much ammunition. With these I intended to protect myself against the Indians. My second idea was that the elevated railroad of New York ran over the housetops in the manner of a roller coaster," Bemelmans wrote in My War with the United States.

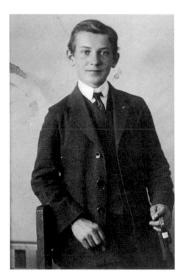

Bemelmans landed in the United States on Christmas Eve, 1914. His father, who had moved to New York and become a jeweler, forgot to pick him up, and he was forced to spend his first Christmas in America on Ellis Island. He and the other immigrants unlucky enough to share his fate were given neckties as Christmas gifts.

While growing up Bemelmans had keenly missed a father figure, and did not easily abandon the idea of being reunited with his father. He found his way to Lampert's home, but he and his father couldn't get along. So Bemelmans was soon on his own, armed only with letters of introduction from Uncle Hans to three of Manhattan's best hotels. He quickly made use of them all, working as a busboy at the McAlpin and the Astor before being taken on at the Ritz-Carlton. It was there that he would largely spend the next fifteen years of his life.

Bemelmans' passport photo, age 16 (above); Below, Ludwig (right) with his father (center) and Emmy (front left).

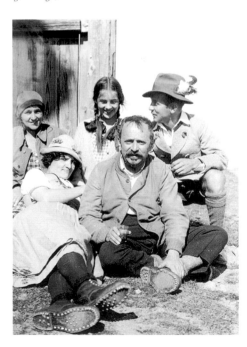

A photo taken by Ludwig on vacation in Austria in the early 1920s. In the front row, left to right, are his father and second wife Emmy, and Aunt Marie and Uncle Hans, with their two sons standing behind.

It was not a life Bemelmans enjoyed. Headwaiters and maîtres d'hôtel became his enemies, and the long hours were brutal. At the Ritz, however, he finally found a place where he could succeed. After a two-year stint in the U.S. Army during World War I, he returned to the Ritz, this time in the banquet department, where he worked his way up to assistant manager, a position with an excellent salary and prestige. By the time he was twenty, he had enough money to buy a car and explore the United States, beginning a lifelong obsession with travel. Bemelmans loved the liberty of America, where he was able to travel anywhere without worrying about having the correct papers.

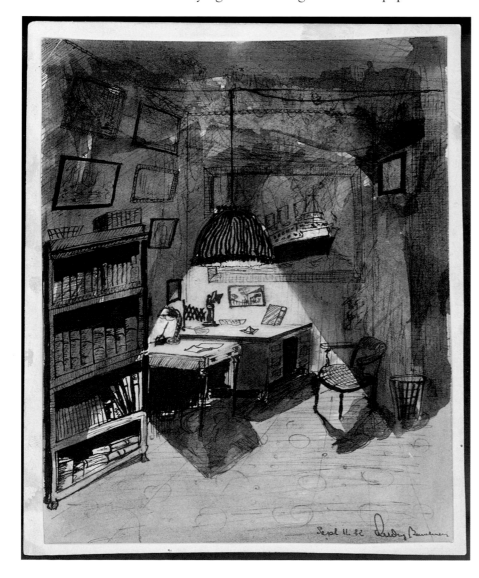

Bemelmans at his banquet department office desk (above); A 1922 drawing of his office (left).

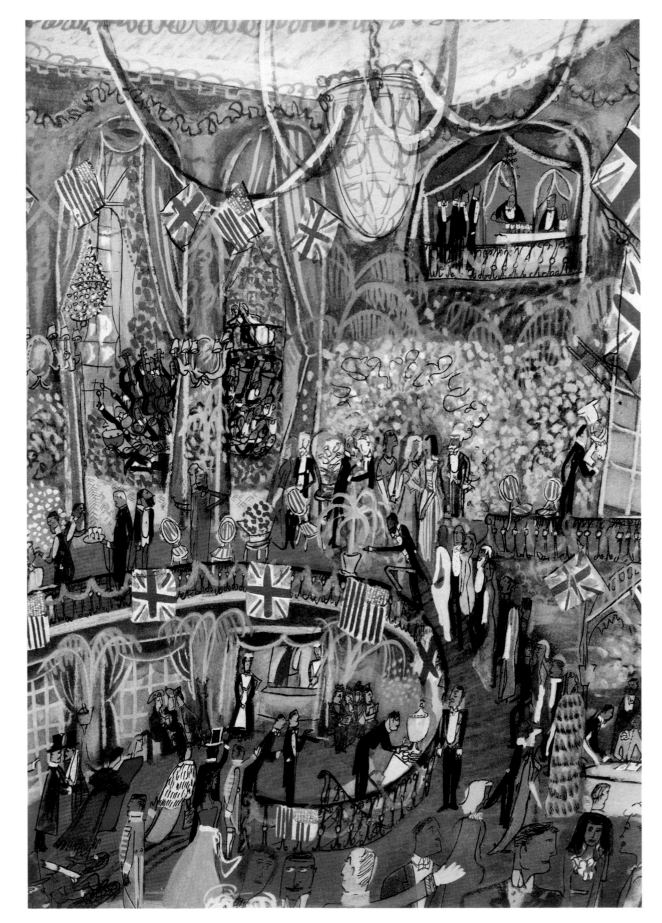

War Relief Ball
at the Ritz.

The Ritz

Bcmelmans wrote and drew of his time at the Ritz-Carlton more extensively than he chronicled any other period of his life. The Hotel Splendide, as he called it, defined Bemelmans for his adult readership much the way Madeline did for his younger audience.

Foremost in all of Bcmelmans' recollections of the Ritz was Albert Keller, a German of immense heft who ran the hotel. He called him Otto Brauhaus in his stories, but he was known to those at the Ritz as "Cheeses Greisd" on account of his favorite expression.

"I shall forever be indebted to the benevolent man Albert Keller, who was my protector," Bemelmans wrote, "who shielded me against the most formidable snob I have ever known, the Maître d'Hôtel of all time, Theodore Titze."

Theodore gave Bemelmans his first job at the Ritz, as a busboy. He was assigned to a waiter Bemelmans called "Mespoulets."

Though incompetent in his profession, Mespoulets taught the young busboy French grammar and encouraged him to become a cartoonist. Bemelmans honed his skills on models the hotel provided.

Bemelmans' sketching provided him with one of his favorite Ritz anecdotes:

Theodore's most esteemed guests were two people whom I called Monsieur and Madame Potter Dryspool, and these he seated at the best table on my balcony. With their arrival everybody fell over themselves, for a complaint from them meant instant dismissal. Madame Dryspool had her special Diet. Monsieur Dryspool was blue from drink.

On the side of the base of the marble column was a stack of menus, the backs of which offered very good sketching surface. The palm there protected me, and I was fascinated with the beauty of ugliness for the first time in my life.

And very carefully I drew the profiles of Monsieur et Madame Dryspool on the backs of two menus. In a moment of haste, the Maître d'Hôtel who functioned on this balcony, who had just wished Madame and Monsieur Dryspool "good morning" and shoved the footstool under Madame's foot, and put away Monsieur's cane with the rubber cup on the end (gout), looked for menus to hand to them—and, thinking I was holding them in readiness for him, tore them out of my hand and handed them to Madame and Monsieur Dryspool—there was a sudden awful sound—a bark from Monsieur and a scream from Madame. Looking at each other's back of the menu, they had discovered the drawings of themselves which, of course, they took for caricature, although they were close likenesses. I then heard the three—Monsieur, Madame and the Maître d'Hôtel— calling Theodore, and I thought it best to go down-stairs, take off my tie and change, and go see the Gish Sisters in The Birth of a Nation.

I expected to be through with the Ritz Carlton after that, and only came back for my things. But the timekeeper said that Mr. Keller wanted to see me.

Mr. Keller said: "Gotdem Cheeses Greisd, they are going to sue diss Hotel and it's all your fault." Mr. Keller never could fire anyone, and he was sorry a moment after he screamed at people. He loved art, and he was a friend of the art dealer Reinhart and of Sir Joseph Duveen; they were both daily guests at the hotel. He told them the story. The two menus with my drawings of Monsieur and Madame Potter Dryspool were in a safe place in his office. He showed them to Mr. Reinhart and to Sir Joseph and asked them: "Has this boy any talent?" and both said "Yes."

Keller assigned Bemelmans to the banquet department. " 'Show your face once in a while—' he said, 'and draw. The ballroom is empty most of the time—or one of the small ballrooms—so you use them as a studio. Your food and room you have, and laundry too, and a salary.'" In the banquet department, Bemelmans worked under Charles Illert ("von Kyling" in the books) and Willy Mladek ("Mr. Sigsag"), who would become Bemelmans' lifelong friend.

Sharing in the prosperity of the banquet department, where he became assistant manager and was thus entitled to a percentage of the profits, Bemelmans began to enjoy "the most luxurious mode of living." He stayed in William Randolph Hearst's suite when Hearst was in California, which was most of the time, and had a violin-playing valet named Herman Struck.

Bemelmans also purchased a Hispano-Suiza, which led to his acquiring a sort-of chauffeur. He wrote:

One of the backstairs family was a Senegalese porter named Amadou, who lived in a tent made of unused rugs under the stairs of the Crystal Room. There he looked through L'Illustration, *and made himself a powerful drink, pouring the leftovers from the various glasses that were removed from banquet tables into a pitcher and seasoning the mixture with lemon and sugar. It was Amadou's ambition to become a doorman or a chauffeur. He went to the Russian tailor who took care of the uniforms of our doormen and had him make a uniform and I employed him as a part-time companion.*

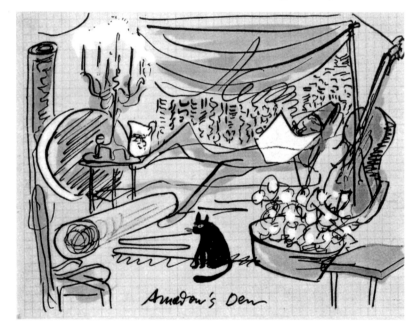

Bemelmans brought over his brother from Regensburg to work at the Ritz, but Oscar missed his hometown tremendously. Ludwig was never able to write about his brother directly, so Oscar became Fritzl in "The Homesick Busboy."

Adieu to the Old Ritz

When the Ritz-Carlton was demolished in 1950, Bemelmans wrote and illustrated a commemorative piece for *Town & Country*, recollecting his years at the hotel. The following is an excerpt.

I forgot to say that I also had a secretary.

Because this was a French hotel, everybody had a French name, and I was known as Monsieur Louis. One day I entered the office, and there was a green slip in the typewriter.

Although there was no business, my efficient secretary sent a daily report to Mr. Keller. She was out of the office, the report was almost finished, I read: Date, department, etc., no parties, no inquiries, etc., and then—"Monsieur Louis came down from his room at ten-thirty. Monsieur Louis had his breakfast in the Japanese garden. Monsieur Louis took the houseman, Amadou, with him. Monsieur Louis said he would be back at three." I sat down at the typewriter and finished the note, writing: "Monsieur Louis came back at three. Monsieur Louis read this note. Monsieur Louis went to the châlet de nécessité and while there Monsieur reflected what a bitch he had for a secretary." I thought that Miss Cutting would find the note and that it would teach her a lesson. Unfortunately she did not read my postscript but signed the report and sent it to Mr. Keller.

He stormed up the stairs the next day at eleven, the note in his hand. He bellowed like a wounded bull. On such occasions he was to be avoided. I took the Hispano—and drove around the country. Amadou sat in the back, for he did not know how to drive. It always took three days for Mr. Keller's anger to evaporate.

During his years at the Ritz, Bemelmans' desire to draw intensified, and the hotel provided many excellent models—kitchen workers and waiters, as well as clientele. Bemelmans dreamed of becoming a cartoonist, a career that he thought would allow him to draw and also earn a good living.

In the picture above, Bemelmans has adopted Art Deco, the style of the time.

An esteemed guest, who lived at the hotel, was a famous cartoonist. He was known for his generosity in tipping and for never looking at a bill. The entire staff from the maîtres d'hôtel to the chambermaids considered him a "gentleman par excellence." Spurred on by a waiter with whom I worked as a bus boy, I decided to become a cartoonist. By 1926, after years of work and countless disappointments, it seemed as if I had achieved my goal. I sat up in the cupola of the old World *building with a group of funnymen: Webster, Milt Gross, Ernie Bushmiller, and Haenigsen. Walter Berndt, who drew "Smitty" in the* Daily News, *helped me a great deal. There was constant laughter in that cupola.*

Unfortunately, there were so many complaints about my strip, which was called "Count Bric a Brac," that after six months, during which no syndicate had picked it up, I was fired. It was a bitter time, for I had to go back to the Ritz; and the old cashiers and the maîtres d'hôtel said, "Ah, Monsieur Bemelmans, who felt himself too good for this dirty trade, is back again. Tiens, tiens [Well, well]."

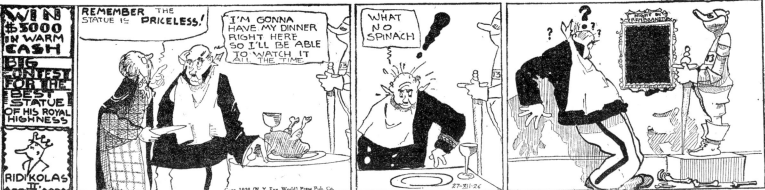

"Thrilling Adventures of Count Bric a Brac" ran one full page in the magazine section of the New York World in 1926. The strip was innovative in design, but failed to catch on with readers. It was canceled after six months; An early version of Count Bric a Brac (near left).

What followed was the bleakest period in Bemelmans' life. He had married an English ballet dancer named Rita Pope, who had come to New York with the Anna Pavlova Company in the mid-1920s. The marriage was tempestuous and soon began to break down. Bemelmans would later write about a ballerina he had been set to marry, but who disappeared when she found out he had been a waiter. But it was Bemelmans himself who was not happy with or proud of his life, and his divorce made him face it.

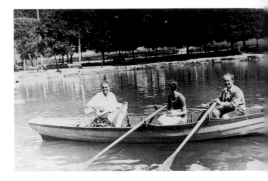

Bemelmans with his first wife, Rita, and his mother.

One day, I looked into one of the many mirrors of the Ritz. The rosy cheeks were more rosy than they had been when I arrived from Tirol, but this was due to indoor exposure. The capillaries had exploded from too much drinking. I had a stomach. I gasped when I walked up the stairs. Morally, I felt as disgusting as I looked, and I said to myself, how many more of these meals, how much more of this life before you look like Theodore the penguin-shaped maitre d'hôtel or, what is even worse, like some of the guests. You will be unhappy, useless, a snob, a walking garbage can. Get out, throw yourself into life. All you can learn here, you know.

In July of 1929 Bemelmans, determined to become a full-time artist, rented a fifth-floor walk-up studio in Greenwich Village. He sold some drawings and in September resigned from the Ritz, with terrible timing. The Depression hit, and people had no money for art. He sold nothing more, and returned to work at the Ritz. Then in August 1931 came the worst. Ludwig's brother Oscar, who had come from Regensburg to work at the Ritz nine years earlier, died after falling down an elevator shaft at the hotel. Bemelmans was overcome with guilt about the accident, for Oscar had never wanted to come to America. Unlike Ludwig, Oscar was born and raised in Regensburg, and he loved the city as much as Ludwig despised it. Ludwig had hoped bringing Oscar to America would save him from Regensburg's crude and small-minded ways. Instead, Ludwig found himself escorting his brother's body back to Regensburg, to be buried in the town cemetery.

Getting fat —
Getting bald —
— no longer young
but getting old — a
miserable failure —
how to end it? You can't
turn on the gas in Frau
STRUCK's kitchen — and to
jump off the 59 ts street
bridge is too cold — Death
by subway is messy and holds
up traffic — Jumping off a
building is not attractiv

Dinner is
ready

A latter-day reflection by Bemelmans on the low point of his life.

The Good Son

Bemelmans wrote of his brother Oscar's tragic death in this story, which is part of *Life Class*, his 1939 collection of autobiographical short stories. Mr. Sigsag, the character who falls down the elevator shaft, is actually a combination of Oscar (at right in photo) and Bemelmans' best friend, Willy Mladak (at left).

It is good that people can lose themselves in weeping, like children. The filthy performance that is a funeral began. I had taken him back here because it was in accordance with his wishes, because it would make it possible for his devout mother to go to his grave and pray for him. He had worked so hard in the Splendide. I had often made fun of him, saying that when he died he would be buried in a dress coat, shrouded in a tablecloth; that a maître d'hôtel would read the service, waiter be his pallbearers, and napkins and aprons hang from the corners of the hearse; and that before they put him in the ground, he would lift the lid of his coffin and change the floral arrangements.

He had died so, in his dress coat, and here was the hearse, drawn by two horses with black plumes and cloaks. The priest was a fat, common man in a shiny, worn soutane. Mr. Sigsag's bells tolled in slow measure while the peasants prayed in a low voice like the even droning of bees. The firemen came, then the veterans, and a singing society. One man with a sky-blue sash draped over his shoulder ran up and down the line of parade with the policeman, who wore white gloves, held his shako in his hand, and carried a saber. These two pushed people into place and arranged the order in which they were to march; they moved the teacher and the schoolchildren up ahead, argued with the band about it, and moved them back again.

When all was ready, the flags of the several societies up ahead were raised; they

began to sway forward, and the people behind them stepped out as they got room. There were chickens and pigs in the street and along the road to the cemetery. When the boys up in the church tower saw the procession start, they rang the bells with a stronger, louder, faster clangor; the peasants raised their voices, the priest raised his, and the few brasses in the band yelled a sad march.

It had rained through the night; the road was slippery and filled with puddles. The parents walked with a will-less stoop, staring ahead, and their monotonous sobbing never changed until it was broken by the mother's shriek when the coffin sank down between the wet walls of the small grave.

The burgomaster made a speech at the grave. He was a big butcher, clumsy, jovial, and bald. His thick red fingers were squeezed into black gloves which he could not quite get up over his hands to button, and he wore an ancient, unkempt, too-small top hat which sat insecure on his head. He began to weep in the middle of his speech, and that started all the men and women off, large tears running down over the peasant faces. The burgomaster became confused, and, in trying to place a big wreath on the coffin, he lost hold of his hat. The hat rolled down the wet earth and fell into the water that had collected at the bottom of the grave. When it was pulled out and handed to him, he looked at it, holding it away from himself, and stopped crying, concerned now with his hat alone. He turned aside and tried to clean it, while the priest delivered his speech of praise of the good son, chanted a last farewell, and sprinkled the coffin.

Through all this, I had watched a child, a little girl who was completely happy and interested. Her slim sunburned feet reached out to the edge of the soggy earth that had been shoveled out of the grave, and she squeezed it in ribbons up through the spaces between her small toes and molded little pies with her arches, bending her toes to hold more of the soft wet clay. In her alone was reason and comfort.

In a time of tragedy for Bemelmans, something good happened. He was introduced to May Massee, a prominent children's book editor at the Viking Press.

> *A typographer brought Miss Massee to my house for dinner. It was a dreary build-*
> *ing of six rooms in a noisy neighborhood. The windows of my living room looked out at*
> *a cobweb of telegraph wires, a water tank, and a Claude Neon sign that flashed "Two*
> *Pants Suits at $15.00." To hide this* mise en scène, *and because I was homesick for my*
> *mountains, I had painted outside of my windows a field with blue gentians, the foothills*
> *around Innsbruck, and a peasant house with a Forester sitting in front of it, on his*
> *lap a wire-haired dachshund, and a long pipe dividing his white beard. "You must write*
> *children's books," decided Miss Massee.*

These illustrations on the window shades, recalling fondly his time with Uncle Hans, would form the basis for *Hansi*, Bemelmans' first book for children. But the publication of that was still several years away, and in 1932, divorced, broke, and still mourning the loss of his brother, Bemelmans suffered the indignity of having to give up his studio and move in with his former valet in Queens, New York.

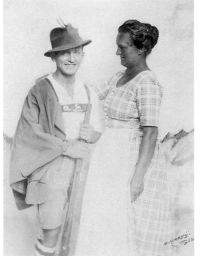 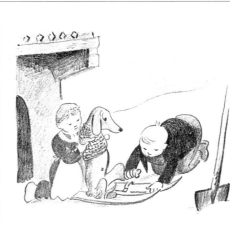 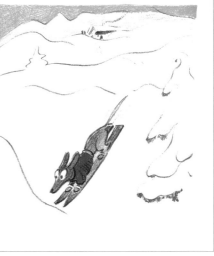

Left to right: Bemelmans with his mother, whom he visited every summer in Europe; The cover of Hansi, *which tells the story of a boy who discovers the good and innocent Tirolean way of life on his Christmas vacation; Hansi and his cousin find out what happens when you put skis on a dachshund.*

But Bemelmans did not give up hope, and hearing there was good money in advertising, he put a portfolio together and knocked on doors. One person who thought he had talent was Ervine Metzl, a commercial artist with whom Bemelmans became fast friends. For his frequent visits to Metzl's studio, Bemelmans would walk across the Fifty-ninth Street Bridge, because he could not afford the five-cent fare.

Suddenly, Bemelmans' luck began to change. He placed illustrations in the *Saturday Evening Post*. Metzl introduced him to a group of advertising executives from Young & Rubicam who gave Bemelmans work, most significantly on a campaign for Jell-O. Metzl also introduced him to a young model named Madeleine Freund who had come to Metzl's looking for work after finding his name in the yellow pages. A married man, he gave Bemelmans five dollars to take her out to dinner.

"And it was the pattern of my life that I should find and marry someone who had intended to become a nun but had left the convent as a novice," Bemelmans would

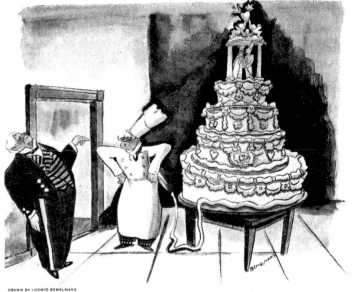

DRAWN BY LUDWIG BEMELMANS
"You May Tear it Down, Adolphe. Madame Has Changed Her Mind Again"

later comment. Freund, whom Bemelmans nicknamed Mimi, had followed her childhood dream of becoming a nun, but unsatisfied, she had quit that life to become a model. Her incongruous career path appealed to Bemelmans; the two fell in love,

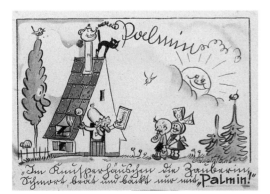

and eloped in November 1934. They were married in the Frenchtown, New Jersey, home of Kurt Wiese, a children's book illustrator who had helped Bemelmans prepare his drawings for the just-published *Hansi*.

Hansi's warm reception did not translate into financial stability, and as for the money he received from the Jell-O campaign, Bemelmans used it to take Mimi out every night

The Saturday Evening Post *published this cartoon in 1933 (above); Mimi in 1935, shortly after marrying Bemelmans (near left); Art for advertisements, such as this one for Palmin, a German maker of lard, provided Bemelmans and his new wife with desperately needed money (far left).*

until it was gone. The newlyweds moved into an apartment above the Hapsburg House, an Austrian restaurant on East Fifty-fifth Street for which Bemelmans provided the murals and management. His pictures made the restaurant a success; his direction almost sank it. His partners—friends from Young & Rubicam—bought him out, and with that money Bemelmans took Mimi on a belated honeymoon to Belgium, where he set his second children's book, *The Golden Basket*.

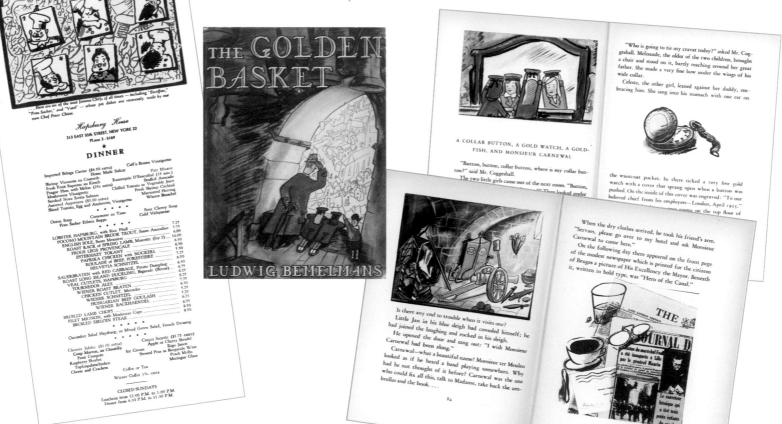

A menu from the Hapsburg House, illustrated by Bemelmans; The Golden Basket, *Bemelmans second children's book, was about two girls on a trip to Bruges with their father.*

Bemelmans quickly spent the money from the sale of the Hapsburg House and soon had to make do with the thirty dollars a week he received for "Silly Willy," a comic strip he had begun producing for a new children's magazine called *Young America*. In *Hansi,* May Massee had guided Bemelmans away from his "cartoonitis" toward telling more of his story with words. With "Silly Willy," Bemelmans fell back on his natural impulses and told the story in pictures, accompanied by spare, rhyming text.

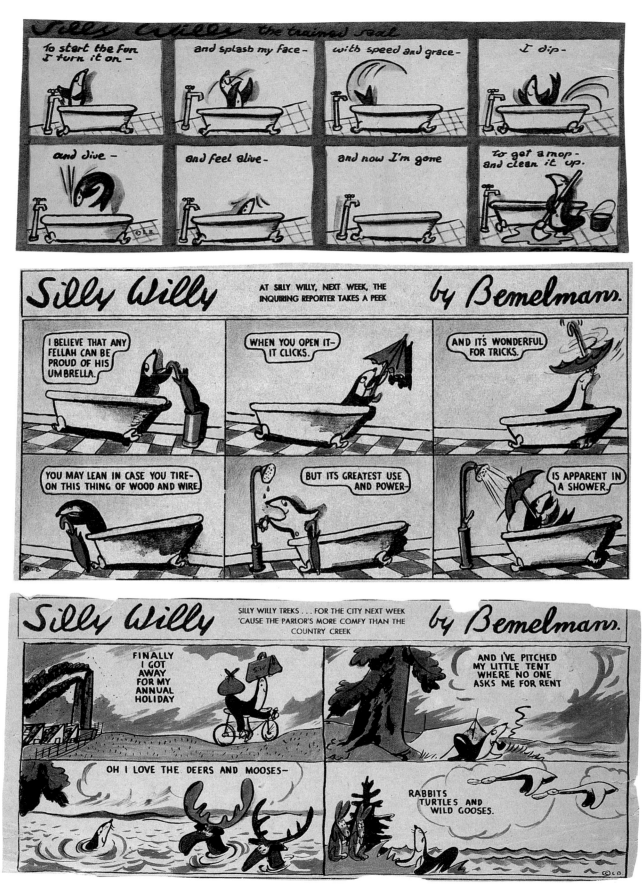

"Silly Willy" ran for a year in Young America, *one of the most obscure magazines of all time.*

As his children's book career was getting off the ground, Bemelmans experimented in a variety of other mediums. In addition to comic strips and restaurant walls, he designed the sets and costumes for a play called *Noah* in 1935, but they went unused because he was not in the union. Bemelmans also got the opportunity to play the part of General Liebfrau in the play *Good Hunting*. But instead of fulfilling his youthful dream of becoming an actor, he was comically bad in the role, and was fired during rehearsals.

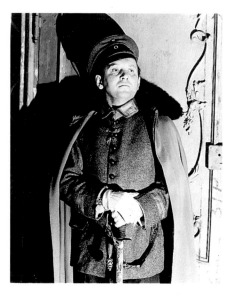

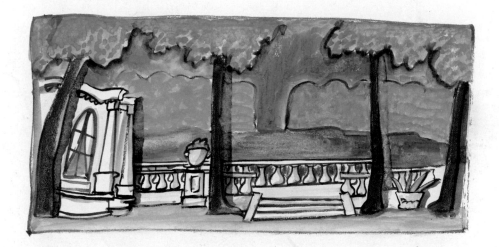

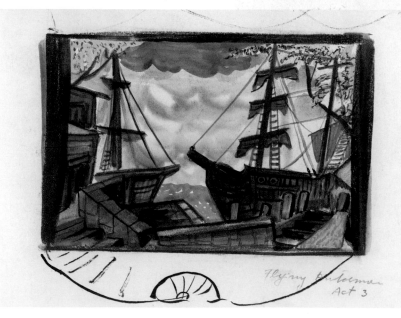

Bemelmans as General Liebfrau (top left);
Two examples of Bemelmans' set designs.

In 1936, Bemelmans illustrated an article entitled "Twin Cities" for *Fortune*. That he was out of his element is clear from the drawings, done in a social realist style to accommodate the story, which concerned strikes and violence. A typical caption read: "THE REVOLUTION MAY COME FROM THE MINNEAPOLIS GATEWAY DISTRICT." Bemelmans enjoyed little of the experience.

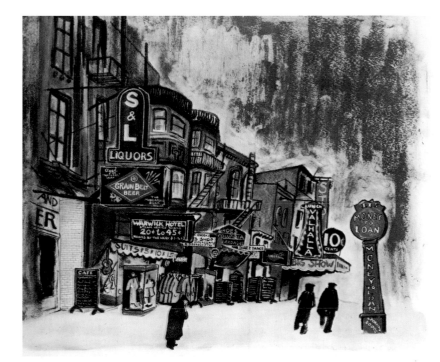

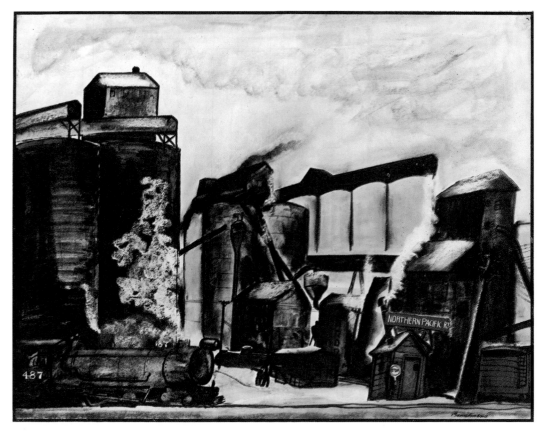

In these two pictures, Bemelmans painted a bleak portrait of Minneapolis for an article for Fortune.

In contrast to some of his experiences with other mediums, Bemelmans' writing for adults met with immediate success. His first short story, "Theodore and *The Blue Danube*," was published in *Story* magazine in 1936. The next year came a breakthrough, as he wrote and illustrated articles and stories for the *New Yorker, Vogue,* and *Town & Country*. His first book for adults, *My War with the United States,* appeared, along with his third for children, *The Castle No. 9*.

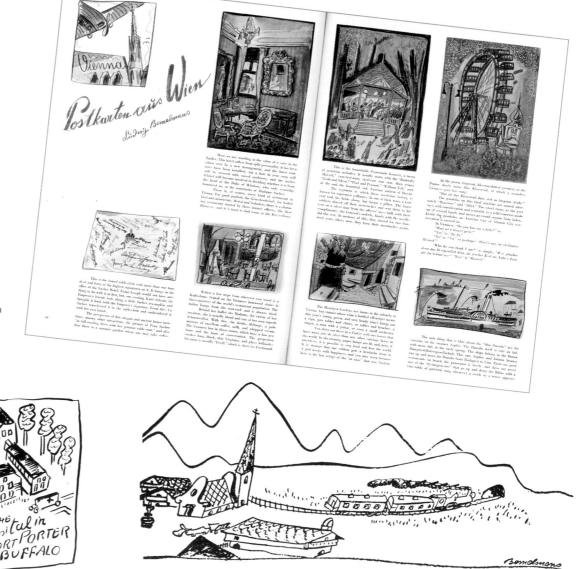

Counterclockwise from top left: Cover of My War with the United States; *An illustration from the book; A drawing from "Theodore and* The Blue Danube"; *An article on Vienna Bemelmans did for* Vogue.

But it was his illustrations for *Noodle*, a story written by Munro Leaf—the author of the previous year's best-seller *The Story of Ferdinand*—that profoundly changed his approach to children's literature. The text was brief, the story and illustrations simple, the book inexpensive, and the project a big financial success. This stood in contrast to Bemelmans' solo efforts, which despite critical success, including a prestigious Newbery Honor Medal for *The Golden Basket,* did not do as well.

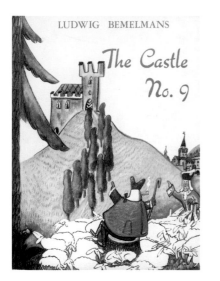

Above: The cover and three pages from The Castle No. 9, *in which a loopy count gives everything its proper name. "Stairs" become "leglifters," the "bed" a "dreambox," etc.; In* Noodle, *the dog fairy grants Noodle the wish to become whatever he wants. Perhaps a giraffe? (right).*

Night on Guard

The following is from a chapter of *My War with the United States*, Bemelman's first work for an adult audience. Published in 1937, the book was based on the diary Bemelmans kept while he was in the army during World War I. He was stationed stateside because of his German background.

After all the soldiers are inspected and have gone to bed, when everybody except a few men out on posts are asleep, I have time to myself.

After the reports are in order, I read, mostly Voltaire, Goethe, a little book of Schiller's poems, and on Napoleon.

Later I go out; the air is so cold that it bites inside the nose, and when I come back I am much thinner.

It is also difficult to walk because the roads are icy, and at times I must quickly slide to a tree, or the wind would take me along across the frozen parade ground.

The clouds race past the moon; there are more stars than I have ever seen in America. In the metallic light, the roofs of the Hospital buildings seem to float in the air in one flat green-silver row of tilted panels; under them the Hospital is quiet most of the time. At times there is a scream from the bad section and then the figure of a nurse passes the lit windowpane, but that happens not very often.

Around the Fort is water, lit as the roofs are, and in this scene is a dangerous ecstasy, an elation which begins as the fear does. It swells up in back of me, high and wide, and as if I were standing in front of an orchestra with rows of instruments wildly playing.

In this excitement many doors open to walk out of the house of reason. The mind becomes acutely clear. This goes through the body, as if the brain, the fingertips, all surfaces, were sandpapered and the nerves laid bare to every sensation. The mind was a little cup and now it is as big as a tub. This happens every night. First of all I feel years older, and whatever I think seems crystal clear. Also I seem able to do anything.

I have had this feeling mildly before, when coming out of a motion picture in which the acrobatic hero has swung himself on a curtain up the side of a tower and jumped on horseback

across the parapets. For half an hour afterwards I have felt like doing the most difficult things in play, to jump, to take hold of anything and swing myself up to the next electric sign on Broadway, to successfully punch anybody in the nose that seemed not worth liking.

Here, now that the Islands of Security are where I know I can reach them, there is the constant wish to walk out further on the thin plank of reason, to gamble with the chance of not being able to come back.

The highest joy, and it is always a boundless happiness, is when the sun rises. It remains resting on the horizon for a long while and then frees itself, floats freely. I feel then a sense of the miraculous logic and divine bookkeeping that makes all things in this world a day older—myself, my mother, the sawmill, the patients, the dead grass under the snow, the trees—and for all these things wells up a rich affection, so that I must put my arms around a tree and feel its being. I also feel the sun, where it has been, with unbelievable detail— the shadows it has thrown past the church in Klobenstein, on the Christuses, on Uncle Joseph who is out with his dog, on the ventilators of the ships on the ocean, and here now on the snow past this tree.

Shortly before the sunrise there is a blue light all over, somewhat like in a theater, where they change the light from night to morning too fast. Unreal, humid and inky, and spattered with yellow street lamps; when you squint your eyes, the streetlights rain gold over the scene. In this light a milk wagon horse clops up the street and a man who has to go to work early comes out of a house always in the same fashion: he yawns, closes his collar, and lets a small dog out after him. He walks down the steps and sees me and lifts his hand in greeting, and then, and always in this same order, bends down to speak to his dog. The ill-formed, unkempt, many-kinds-of-dog makes a creaky sound, scrapes and scratches, and is beside himself with gratitude. He shows this with all his might, wiggling so that one moment his head looks at his tail on the right side of his body and then on the left. It is his daily morning prayer to his master and for himself to show how glad he is to be alive and how grateful to be a dog.

Then the sun rises, it places light on ice-covered branches and on a young oak leaf that has stuck through wind and winter. It is curled like the webbed claw of a bird and becomes liquid and gilded.

In his fourth book with May Massee, *Quito Express*, Bemelmans radically changed his style. The influence of *Noodle* was clear; the text was now dominated by the pictures, which were dramatically simpler than those of his earlier work. Bemelmans came to trust his own instincts more and was less inclined to create what was traditionally considered "children's literature." He began a book based on his comic strip character Silly Willy, which he knew would not be a Massee book. He had only completed a first draft, however, when a series of events conspired to make him drop the project in favor of a new one.

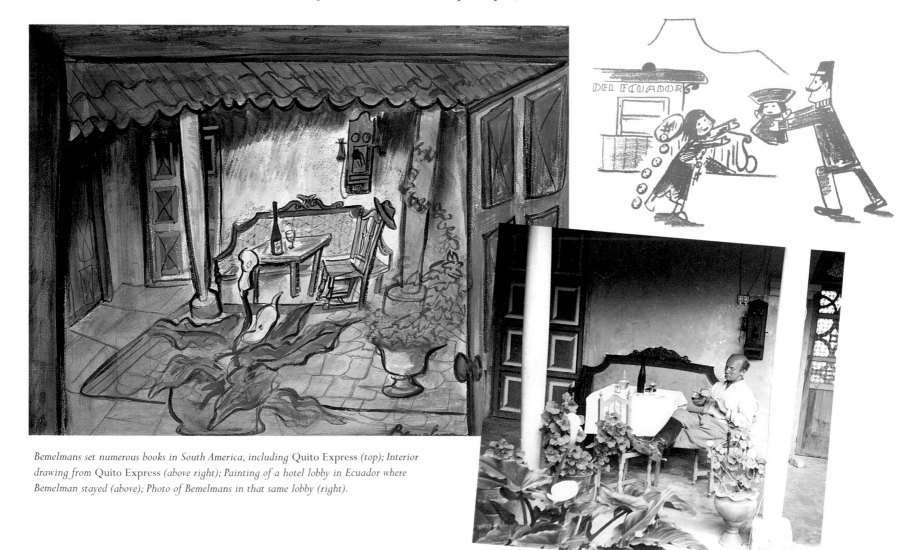

Bemelmans set numerous books in South America, including Quito Express *(top); Interior drawing from* Quito Express *(above right); Painting of a hotel lobby in Ecuador where Bemelman stayed (above); Photo of Bemelmans in that same lobby (right).*

Ldwj Bemelmans

Bemelmans' photos and sketches (above) show his fascination with Ecuador—a mountain country, but very different from Tirol. The differences between sketch (right) and published illustration (far right) show the change his art underwent while working on Quito Express.

Pedro and the train was gone.

In 1938, Bemelmans took Mimi and their two-and-a-half-year-old daughter Barbara to France. The birth of his first and only child had a profound effect on Bemelmans professionally. When his comic strip "Count Bric a Brac" was floundering, a newspaperman friend of Bemelmans' had told him that he would never be a great cartoonist until he had an American child. And here one was, providing Bemelmans with not only insight into his audience, but an inspiration for his work. Their trip started in Paris, where Bemelmans fell in love with the city which would eventually become his second adopted home. While in the south of France, Bemelmans' bicycle collided with the only motor vehicle on the Île d'Yeu. In his hospital room there was a crack in the ceiling that looked like a rabbit, and next door was a young girl having her appendix out.

From top right clockwise: Mimi, Barbara, and Ludwig; Drawings of the fateful bicycle; Painting from the Île d'Yeu; Photo of Barbara; Drawing from the Île d'Yeu; Ludwig and Barbara; The baby in this photograph is not Barbara, but Bemelmans sent it to his mother and pretended it was because he could not afford to have his daughter photographed.

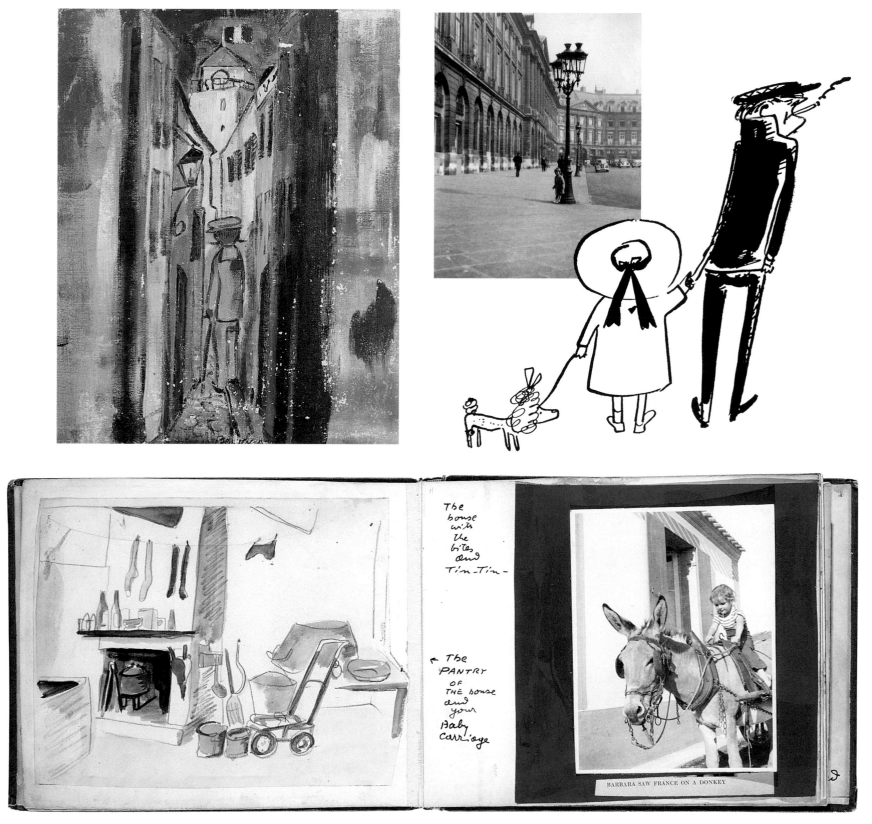

Pages from a scrapbook Bemelmans made for his daughter (above and top center); Drawing of Barbara with her French nanny, Georges (top right); Painting from Île d'Yeu (top left).

Bemelmans came back to America with the story and setting he needed for a new book. The character, he had been developing for some time. A comic strip he had sketched years earlier featured a nun with six girls in her care, one of whom breaks off from the group and gets into trouble. A character with copper red hair appeared in *The Golden Basket;* her name was Madeleine and she was the smallest of a group of girls living in a convent.

Bemelmans also remembered his mother's stories of convent schools, the little beds in two rows, the two straight lines, the girls all dressed alike. He would later say that his creation was a combination of his mother, wife, and daughter, but certainly it was also part Bemelmans himself—the smallest in class, the one always in trouble.

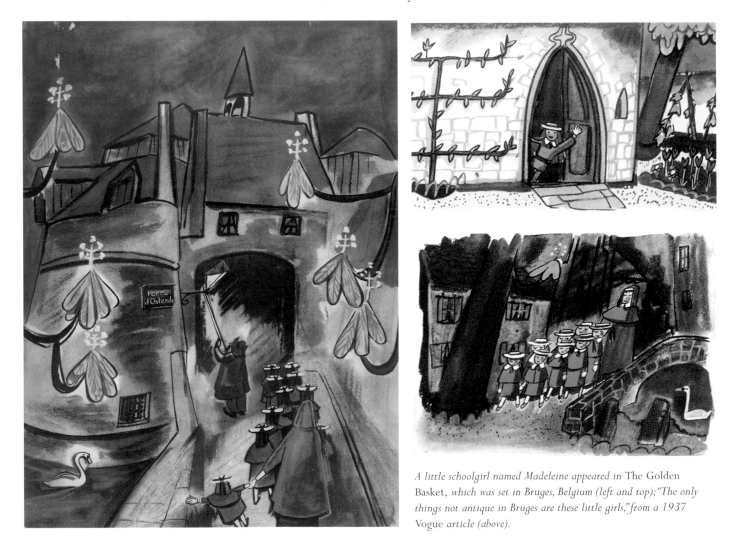

A little schoolgirl named Madeleine appeared in The Golden Basket, *which was set in Bruges, Belgium (left and top); "The only things not antique in Bruges are these little girls," from a 1937* Vogue *article (above).*

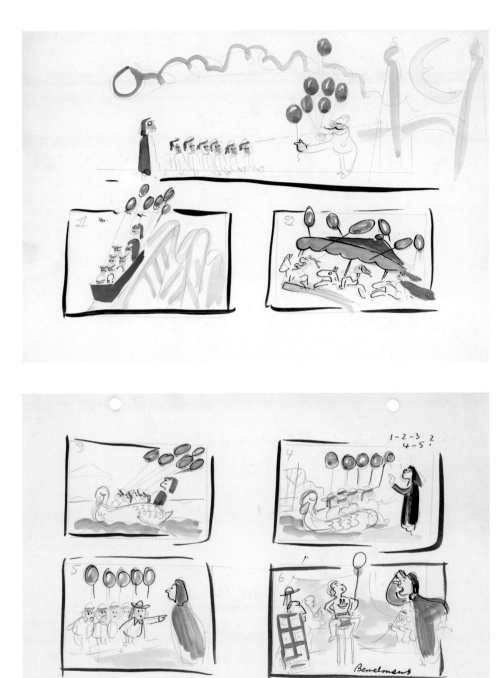

*The forerunners of Madeline: Ideas for a comic strip (above); A pair of Madeleine
sketches (right). Bemelmans dropped the second "e" in Madeleine because
Madeline was easier to rhyme.*

At Pete's Tavern, the old Gramercy Park speakeasy that was one of his favorite haunts, Bemelmans set to work. Using the back of a menu, as he had done thousands of times at the Ritz, he wrote, "In an old house in Paris / that was covered with vines . . ."

Bemelmans took *Madeline* to May Massee but she rejected it, either for being too sophisticated for children or for having drawings that were too cartoonish—perhaps both. Simon and Schuster promptly published it.

Madeline was not right for Bemelmans' mentor, just as "Silly Willy" wouldn't have been. He had produced a work outside the bounds of traditional children's fiction, one that incorporated the best of high art—painting, poetry, and children's literature—with the storytelling methods and graphic simplicity of the supposedly low comic strip.

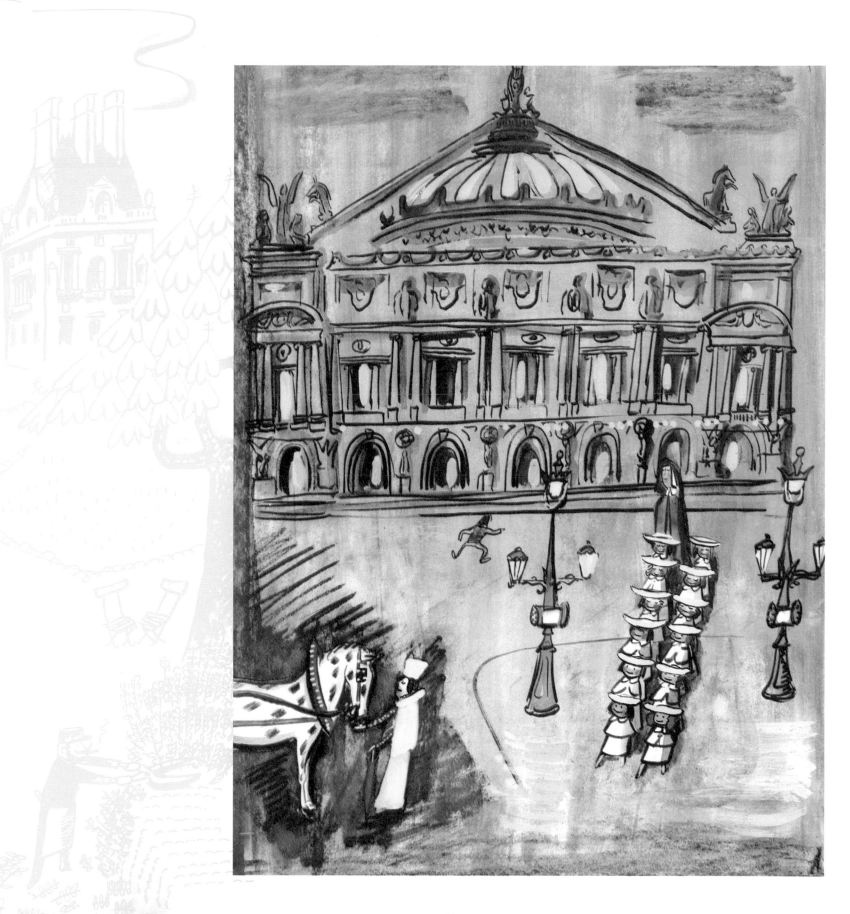

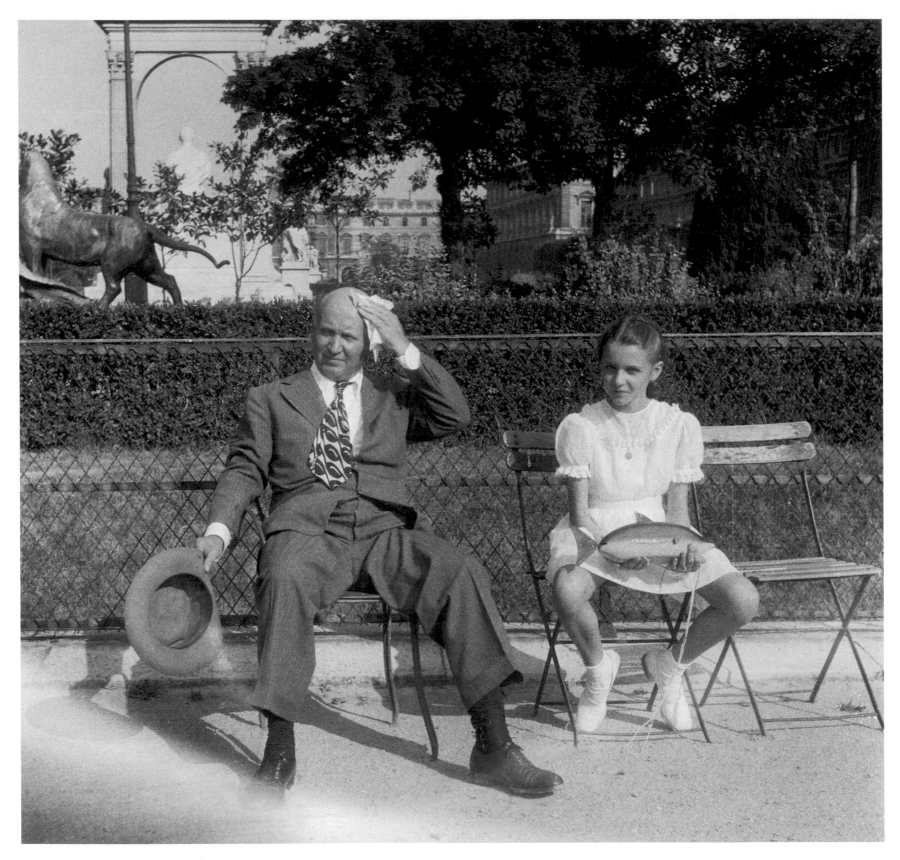

Bemelmans and his daughter Barbara in Paris, 1947.

Part II
1940-1950

"I hate to order round-trip tickets; I go one way, because I hold before me the possibility I may never come back."

—From "Invitation," To the One I Love the Best

far away from war and blood
and the cannons awful thud
with no need to run or scud
lived a Rabbit named Rosebud

*M*adeline was an instant hit, although many reviewers of the time agreed with Massee that it was too sophisticated for children. The book received a Caldecott Honor and earned Bemelmans wider fame.

Bemelmans' next children's book, *Fifi,* like *Madeline,* was in verse. But with 1942's *Rosebud*—Bemelmans' take on the old African trickster tale—he returned to prose. However, Bemelmans did write a version of *Rosebud* in rhyme, one that was superior to the published text. It began, "Far away from war and blood / and the cannon's awful thud . . . " Unused pictures portrayed rabbits in

An unused picture and verse from Rosebud *(opposite page); Drawing from* Fifi *(top); The cover of* Fifi *(far left); Cover of* Rosebud *(left).*

tanks and in uniform. The onset of World War II may have driven Bemelmans to change the parts of *Rosebud* that suddenly seemed frivolous and inappropriate. Whatever his reasons, Bemelmans would not produce another children's book for the duration of the war and the dark period in Europe that followed.

Instead, Bemelmans concentrated on other kinds of writing, publishing his first novel, *Now I Lay Me Down to Sleep,* in 1943. In all, Bemelmans turned out nine books for adults in the 1940s, including four novels. He tended to use the novel form when he dealt with serious subjects, while his autobiographical stories were generally lighthearted. Three of his novels of this period dealt with the effects of Nazism on Europe. Bemelmans could easily imagine the tormentors of his youth, the teachers and "potato heads," falling under the Nazi spell. He had also had some direct contact with Nazis during his summer vacations in the 1930s.

On one trip to Germany, a draft of *The Golden Basket* was confiscated. It was returned with the remark that it was a very nice book. On another, he had brought his new wife Mimi to meet his mother. Hitler was arriving at his retreat in Berchtesgaden when Bemelmans and his family were in a local pub. For Hitler's homecoming speech, the local party members placed a radio speaker under a portrait of the Führer. The end of his speech was met with a hearty round of "Heil Hitler"s accompanied by Fascist salutes directed toward his mountain-top retreat, right behind where Bemelmans was seated. Bemelmans rose, took the stub of his cigar and, placing it atop his upper lip, launched into his best Hitler impression. Thinking nothing of it, they returned to their hotel, where Mimi, on a lark, painted her husband's toenails pink while he slept. The next day Bemelmans was arrested. When the toenails were discovered, his jailers said, "Oh, he's one of them," and threw him into a cell for homosexuals. Mimi rushed to the American consul, who obtained his release. It was his last trip into Nazi territory.

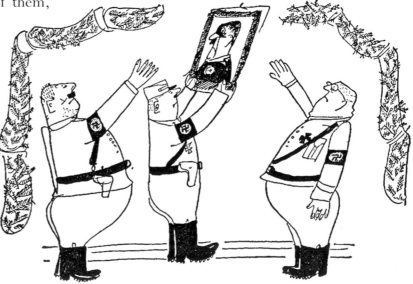

Three of Bemelmans' books from the early 1940s (left); An illustration from his story "Bride of Berchtesgaden," in which Bemelmans recounted how he landed in a Nazi jail, although he made no mention of his pink toenails.

While others saw the banality of evil, Bemelmans wrote of the buffoonery and boorishness of the Nazis, most directly in *The Blue Danube,* a 1945 novel set in Regensburg, Germany. Bemelmans was haunted by what was taking place in the city of his youth. In the early 1920s, his brother Oscar had been in love with a Jewish girl named Irma Loeb, but her father forbid her to marry a Catholic. Bemelmans had always wondered if the marriage would have saved Oscar, and after Irma and her family died in Dachau, he wondered if it could somehow have saved them as well.

The Blue Danube *cover and two interior illustrations.*

The Blue Danube began life as a story for a movie. Bemelmans spent much of World War II in Hollywood, working as a screenwriter for MGM. Only one of his stories made it to the screen: *Yolanda and the Thief* (1945), a musical comedy starring Fred Astaire. He wrote about his experiences in Hollywood in the novel *Dirty Eddie,* which concerned a star pig whose agent holds out on movie mogul Moses Fable for more money. Its unflattering portrayal of movie executives did not endear Bemelmans to the studios. Louis B. Mayer, on whom Fable was based, reportedly said, "Never hire that son of a bitch again, unless we absolutely need him." Although the work was frustrating, Bemelmans enjoyed life in California—the beach, horseback riding, and his newfound friends, Sir Charles Mendl and his wife, Elsie de Wolfe.

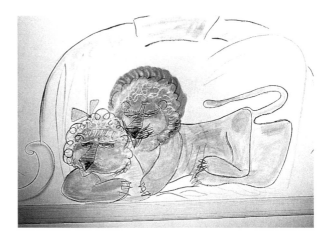

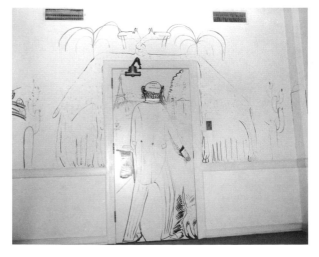

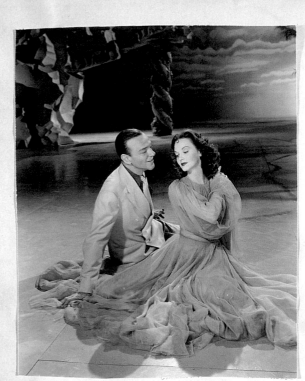

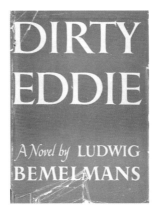

Two murals from Bemelmans' MGM office (far left). In the top one, the male lion carries Louis B. Mayer's likeness; A literary caricature of Mayer appeared in Dirty Eddie *(1947) (above); Publicity still from* Yolanda and the Thief, *with Bemelmans' caption (left).*

Invitation

To the One I Love the Best is Bemelmans' 1955 ode to his friendship with Elsie de Wolfe, who is credited with creating the profession of interior design. In her, Bemelmans found a kindred spirit, one who also exorcised demons through work and celebration. The following is from the beginning of the first chapter.

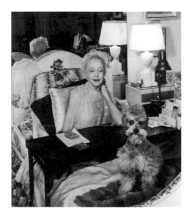

I believe in God; to me He has been wonderful, kind, and generous; but I have never been able to convince myself that after I have passed through this magnificent world I'll be admitted to a place even more astonishing, to a paradise of better landscapes, restaurants, horses, dogs, cigars, and all the other objects of my adoration; for such would be my paradise. I cannot imagine myself as an angel, sitting on a cloud, forever singing, and I think that it would bore God himself.

For such as I, then, all is here and now, the rewards and the miracles. They are the green tree, the sunrise, and all the things we sing about—the jet plane, the paintbrush and the easel, the cadets of West Point, and especially children, most of all babies with their grave, observant eyes.

In spite of all that the black moods descend upon me, and consolation is hard to find. I can't be helped by psychiatrists, for, of those I know, several have committed suicide, a dozen have been divorced, and the best of them have the look of the haunted and bewildered or radiate the false effusiveness of the overstimulated. I lie on my own couch, suspended in cosmic gloom, the eye turned inward, and it takes me a while to console myself.

There are two cures. One is to work; all misery fades when I work, but I can't work all the time. The other is to celebrate. I, the confirmed lover of life and professor of happiness, look as we all must at life, and at the approaching day when we can only hope to be mourned for. I get hungry again and have to hurry and reassure myself with another good bottle and a fine meal, and after the coffee I look through the blue smoke of my good cigar. I sit in the melancholy mood that is like cello music and search for the answers we shall never know.

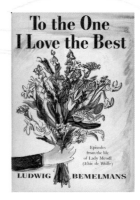

In To the One I Love the Best *(above), Bemelmans estimated that Elsie de Wolfe (left) was ninety years old and weighed the same number of pounds as when he met her—a fragile casing for an iron will.*

After the war was over, Bemelmans traveled extensively through Europe on assignment for *Holiday* magazine, producing a series of articles and paintings. These were collected in 1948 in *The Best of Times*, his one book of serious nonfiction. This was not the Europe of *Hansi*, *The Golden Basket*, and *Madeline*. In his foreword, Bemelmans wrote:

> *I set out to write a happy book. The mood was somber, then as it is now, but I disagreed with the opinion that was screamed at us from the radio and the front pages, that this was "the last chance of civilization."*
>
> *I had, and have, too much faith in people to lean in that direction. I don't believe there is such a thing as a "bad people." There are in my opinion only misguided people and rotten governments. . . . I wanted to go then and report the patient's recovery—of which I was, and am, certain.*
>
> *However, outside the crystal-lit salons of palace hotels, and a few choice fun places to which the various travel agencies and tourist offices pointed with eager fingers, and here and there an out-of-the-way place that was untouched, there was little gaiety. One would have had to travel blindfolded in the dark stretches that lay between.*

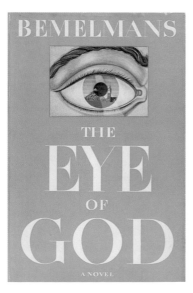

Bemelmans as a correspondent in postwar Europe (above); His visits provided the material for three books (right); The two rose drawings come from The Best of Times.

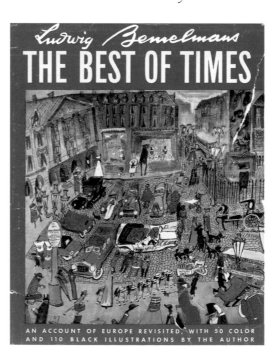

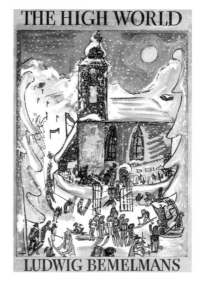

In Tirol, which Bemelmans had visited the previous year, he found things particularly bleak. Tirol, now part of an independent Austria, was in the clutches of bureaucrats. He found Tirolean innkeepers buried in regulations: ten rules governed the serving of soft drinks alone. In *The Eye of God* (1949), his most ambitious novel, he chronicled life in the mountain town of Aspen through three generations, from the nineteenth century through the de-Nazification process.

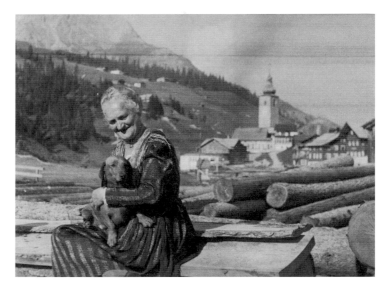

Aspen was based on the village of Lech am Arlberg in the Austrian Alps, where Bemelmans' mother lived during the war and until her death in 1951. Ironically, Bemelmans' father Lampert died the same year.

Despite his father's transgressions, Bemelmans had stayed in contact with him through the years and even helped to support him. Lampert had speculated in Florida real estate during the 1920s, but the hurricane of 1926 wiped him out, reducing him to selling painted coconuts on the side of the road for a time. But happily for Lampert, and somewhat amazingly, he was able to enjoy a successful second marriage.

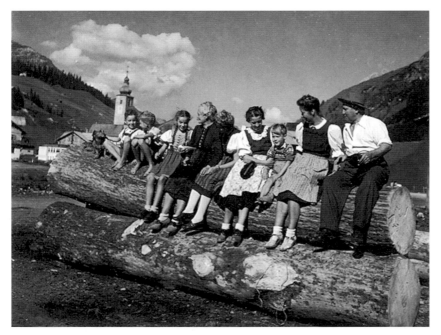

Bemelmans' mother (above) lived with the Mosbruggers, who owned an inn in the Austrian Tirol; At left, Bemelmans (far right) and his mother (fourth from left) with Irma Mosbrugger (fifth from left) and her family in 1947—as a boy, Bemelmans had worked for Irma's father, who was a protégé of his Uncle Hans.

The People You Write About

In 1947, Bemelmans took his eleven-year-old daughter Barbara on one of his trips to Europe. He wrote about the trip in *Father Dear Father* (1953). He used Barbara as a sounding board for reflections on his work and his life in general.

The following excerpt is taken from the chapter "Rome Express," in which father and daughter take the train from Paris to Rome

Barbara doing homework on a train in France during the summer of 1947.

In the compartments of European sleeping cars there is hardly room to turn around when the beds are made. The door between mine and Barbara's was open. She was sitting up in bed, with Little Bit beside her, eating a can of American spaghetti, which she had heated on an alcohol stove. She was taking to Italy a supply not only of this specialty, but of American dog food for Little Bit.

The train went "ta-dang, ta-dang, ta-dang, ta-dang," then changed over to "cluck-cluck, clickety-cluck," and then resumed its "ta-dang, ta-dang, ta-dang, ta-dang, ta-dang." The rhythm was very conducive to thinking, and easy to set words to. I swayed back and forth, standing at the window. I can stand there for hours very happily, especially in the night.

Before retiring, I called into the next compartment, "Barbara, are you still awake?"

"Yes. Has that character of yours finally gone to bed?"

"What do you mean by 'that character of yours'?"

"Oh, international society—counts, dukes, Mrs. Whoozit, General Leonidas Millefuegos—your snob friends."

"I beg your pardon?"

"Well, Poppy, the people you write about and sometimes draw and paint."

"What's wrong with them?"

"Well, you're very fond of them, and you make them out the only people worth while."

"Some of them are my friends. Some of them are very interesting. Some of them are complicated and rare people who entertain me——I don't mean with wine and food, but by their curious nomenclature and the details of their personalities——their dress, ideas, means of locomotion. I love to watch them."

"And some are awful——most are."

"Yes, some are awful, and I have portrayed them as best as I can. I have written some very bitter social satire."

"Well, I'm sorry, Poppy, but I never got that. You make them all charming and too, too utterly divine."

"I'm not a prosecutor. I don't condemn. I put the form, the shape, the being, on canvas and on paper, and I let the reader decide for himself."

"Well, maybe you start out that way, and then, no matter how awful, you fall in love with your characters, and they all turn mushy and nobody is really bad——they're just odd. In fact, sometimes the bad are much more lovable than the good. And now that I come to think of it, almost always. Anyway, it's not social satire."

"Well, maybe it's not social satire but comedy of manners——and in a world in which there are less and less manners, especially among the young, it's a very hard thing to write. As for hating people, I'm sorry, but I find it hard to hate anybody, and impossible to hate anybody for long."

"That's what Mother says. She says you love too many people."

"What else does Mother say?"

"She says that you're very fortunate."

"Why?"

"Because everything that makes you happy can be bought."

I listened to the "ta-dang, ta-dang, ta-dang" of the wheels and hoped Barbara would go to sleep.

"Poppy, are you still awake?"

"Yes. What else?"

"Oh, nothing. I was only thinking about what other kinds of people you write about, and I remembered. It's bums and crooks, and they always come out all right too. So you write about the bottom and the top, but never about the between."

"The people in between?"

"Yes. What's wrong with them—the normal people, the people—"

We passed several minor stations while I busily searched my mind for plain people that might have appeared in any of my works.

Barbara said, "Come to think of it, even the animals are strange in your books, like that little dog that belonged to the magician in Hotel Splendide."

"Well, a magician wouldn't be satisfied with an ordinary dog."

"What are you thinking about, Poppy?"

"Ordinary people."

"Well, what's wrong with them?"

"Nothing's wrong with them. I love them, and I'm sure I've written about them with understanding—sometime, somewhere."

"Your common people, Poppy, are all headwaiters with Cadillacs, and valets and gardeners." A few seconds passed, and then she added, "Or French."

More Conversations with Barbara

From "Science and Man," *Father, Dear Father*, 1953

On the balcony Barbara was now doing her homework. She did it faithfully every day, and in a silence she should have found disturbing. I was surprised that she was able to work, for in New York, in a cluttered, disorderly room, she has the radio going, and the television set. She talks on the phone while she watches Red Skelton on television and listens to any gags that might be interesting on the radio, switching her attention from one to the other and saying, "Listen, Frances, did you hear that? Groucho just said—"In addition to all these goings-on she has a pencil poised on a piece of paper and is doing algebra. The miracle is that her report card is marked "very good" in all subjects, and "excellent" in deportment.

The cloud was up now, hiding the cone of Vesuvio—it was white and gray. I heard the clock towers of Naples bonging out six o'clock. It was time to go out, and I said, "Hurry up, Barbara."

Gathering up her books, she said, "Poppy, will you ever learn that it's not 'hairy ape' but 'hurry up'?"

I am at times astonished myself that I have been unable to shake off my Austrian accent. I, of course, cannot hear myself, but since I have lived in America from the age of seventeen, it is curious how strong the accent still is.

"Poppy, do you think in German?"

"That's another thing that puzzles me—no, I don't."

"In English?"

"No, I don't think in either. I think in pictures, because I see everything in pictures, and then translate them into English. I tried to write in German; I can't. I made an attempt to translate one of my books, and it was very difficult and sounded awful. Then the Swiss publishers Scherz engaged an old lady, the widow of a German general, to translate the book, and when I read it I said to myself, 'How odd! It's another book.' I liked it, but I could never have done it myself."

"What do you mean by pictures?"

"Well, when I write, a man comes in the door. I see it as a movie—I see the door, precisely a certain kind of a door, and I see the man."

"In color? Do you dream in color?"

"That depends on the subject. Happy dreams are usually in color, especially flying dreams."

"How do they go?"

"They are the best, and I have them after indigestion sometimes, when I eat late and heavily. I am like a bird, and I fly all over and see everything from high up, which is my favorite perspective."

"And you have no vertigo?"

"None whatever. I fly at will low over the ground and swing up and sit on the edges of high buildings, and visually it is the greatest pleasure."

"You love painting more than writing?"

"Yes, I would rather paint than write, for writing is labor."

"Do you think you could be a great painter?"

"Yes, the very best."

"But why aren't you?"

"Because I love living too much. If I were unhappy as Toulouse-Lautrec was, or otherwise burdened, so that I would turn completely inward, then I would be a good painter. As is, I'm not sufficiently devoted."

"Is it the same with writing?"

"*Well, yes. My greatest inspiration is a low bank balance. I can perform then.*"

"*To make money?*"

"*Yes, to make money.*"

"*But that's awful!*"

"*Well, it has motivated better people than I.*"

"*For example, whom?*"

"*For example, Shakespeare.*"

"*And if you had all the money in the world would you just be a café society playboy and waste it?*"

At such turns in the conversation I impose silence.

"*Do you speak German with an accent too?*"

"*Yes, of course.*"

"*Do you speak any language correctly?*"

"*Well, I have the least accent in French, or else the French are very polite, for they always say how very well I speak it for a foreigner.*"

"*That's all rather sad, Poppy.*"

"*Well, it has its advantages. It's like being a gypsy, belonging everywhere and nowhere. When you are in Paris you want to be in New York and vice versa. You are made up of fragments—and just now it occurs to me it's a good thing that you know what you want to be, an American, that you speak your own language well. Stay that way, and don't let anybody change it—and now we really must hurry up.*"

"*Poppy, try saying 'Hurry up.'*"

"*Hurry up.*"

"*That's better.*"

As always, Bemelmans' home base remained New York, in particular Gramercy Park, where he lived in various buildings including the Hotel Irving, the National Arts Club, and

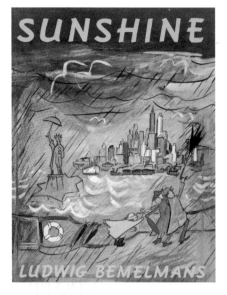

the Stuyvesant Fish House. In the late 1940s, the neighborhood inspired him with an idea for a movie. It was to be a musical comedy vehicle for Frank Sinatra, and the treatment Bemelmans wrote for it was set in the neighborhood around Gramercy Park and concerned a music school, the postwar housing crunch, and a villainous landlord named Mr. Sunshine. This formed the kernel of *Sunshine*, with which Bemelmans returned to children's literature.

Sunshine followed the formula Bemelmans had developed in *Madeline*: the rhyming verse, the mix of black-and-white line drawings and expressionistic gouache paintings, the school of children with a benevolent female overseer, and the use of a city as a central character. What

Sunshine begins with a picture of Gramercy Park (below), and the lines, "The boy has a poodle, the girl a setter, / And Mr. Sunshine is mailing a letter."

Bemelmans had done for Paris he now did for New York, using city landmarks such as the Statue of Liberty, the Empire State Building, and the Brooklyn Bridge as the backdrop for his story.

This marked the first time Bemelmans had turned to America for inspiration, and with the exception of the Madeline series, all the rest of his picture books would be set there. Perhaps this was because he found Europe to be a bleak place, not the proper setting for a children's book—indeed, with the end of World War II the attention, hopes, and dreams of the world had shifted to the United States.

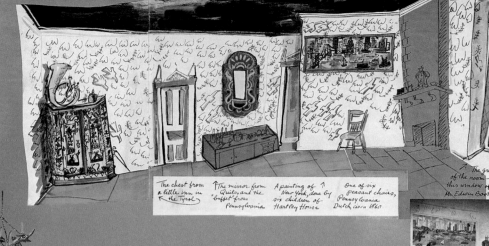

Ludwig Bemelmans Splendide Apartment

The chest from a little inn in the Tyrol

The mirror from Quito, and the buffet from Pennsylvania

A painting of New York, done by six children of Hartley House

One of six peasant chairs, Pennsylvania Dutch circa 1860

The greatest asset of the room—the view from this window of the statue of Mr. Edwin Booth in the park below

The colour of the mantelpiece is genuine Bemelmans, the clock comes from the Castle of Nymphenburg

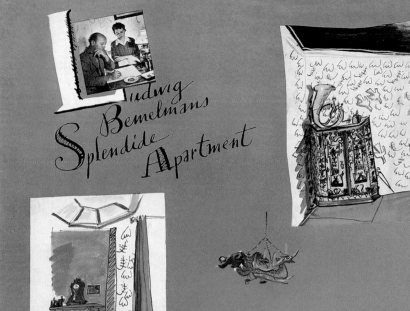

Indians deliver the mirror to the hotel in Quito

Bemelmans presented his "Splendide Apartment" with a view of Gramercy Park in a 1942 issue of Vogue *(top). Lüchow's was just down the street. He frequented the restaurant (right) for over forty years, and even illustrated their popular cookbook and a matchbook cover (below).*

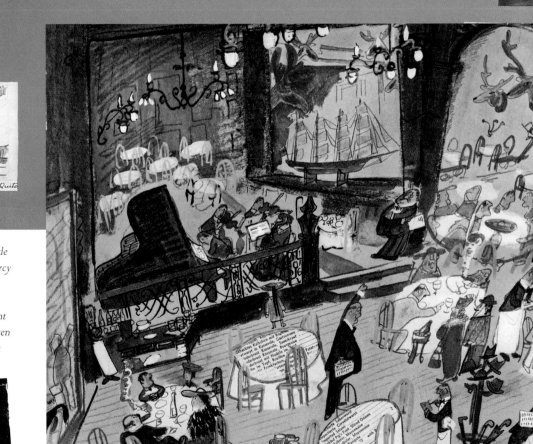

Bemelmans' next children's book, *The Happy Place* (1952), was set in another of his favorite New York spots, Central Park. He had already painted Central Park for the covers of the *New Yorker* and *Town & Country*. In 1947, he had painted murals in what would become the Bemelmans Bar of the Carlyle Hotel. He had depicted the park as it would be if people were in cages in the zoo and animals roamed around on afternoon strolls with their families. As payment, Bemelmans and his family got to live in the hotel for a year and a half.

The Happy Place *is about Winthrop, a department store rabbit who finds his freedom in Central Park.*

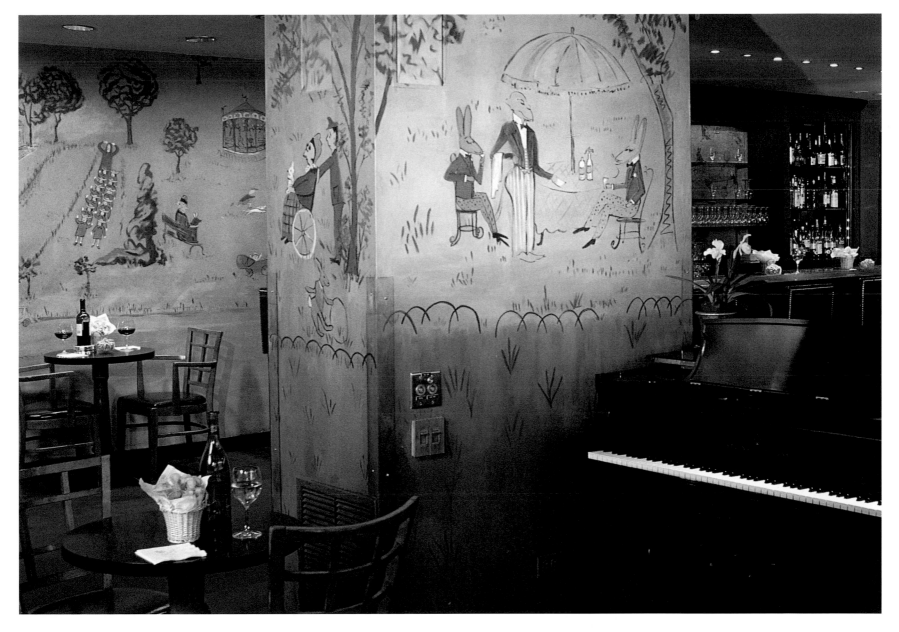

Of all Bemelmans' murals, the only ones
that still exist and can be seen by the
public are at the Bemelmans Bar, which
is in the Carlyle Hotel in Manhattan.

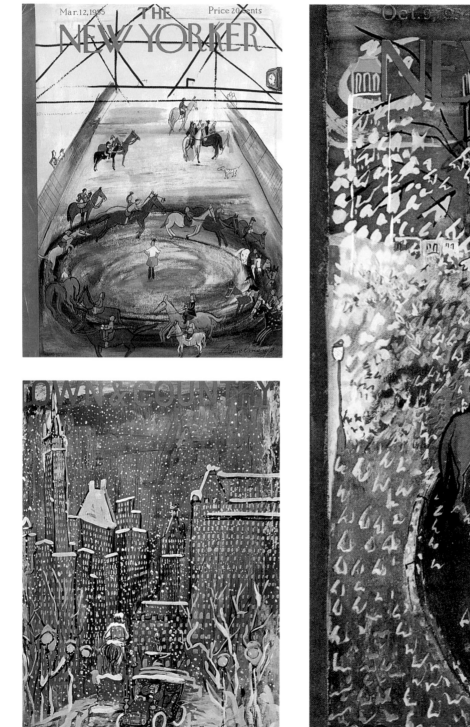

Bemelmans' covers for magazines, especially the New Yorker, were an excellent source of income and prestige. They also helped to build a following for Bemelmans' painting. Riding in Central Park, along the bridal path often taken by Bemelmans' daughter (above); A horseback riding lesson (top left); A wintry drive through Central Park (bottom left).

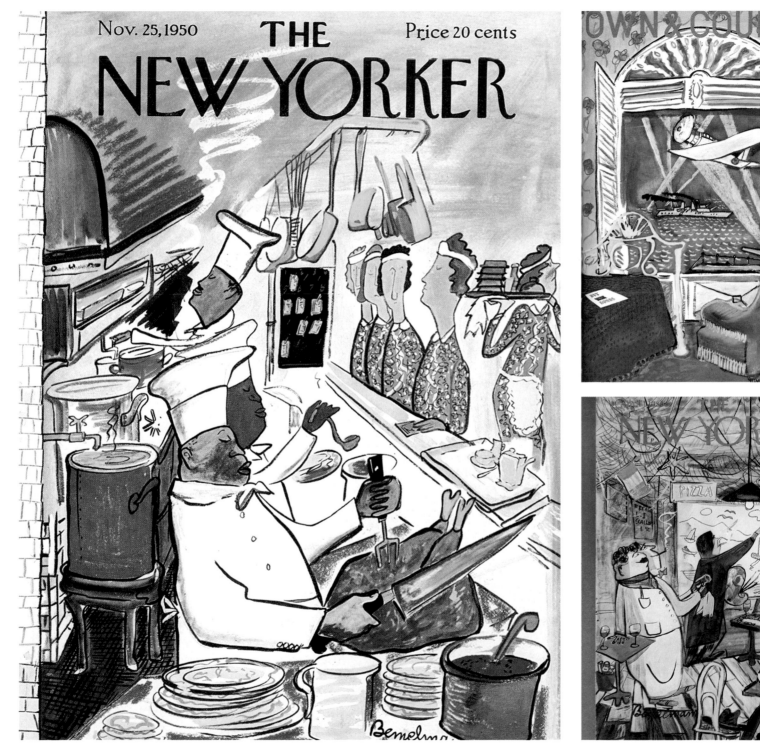

The kitchen of the White Turkey, a restaurant in Connecticut that Bemelmans owned in partnership with his father-in-law (above); A patriotic cover from World War II (top right); A mural being painted in an Italian restaurant (bottom right).

Bemelmans' trunk served as his traveling studio.

Part III
1950-1960

"There is Life in Everything—why didn't I paint it long ago?"

—Scribbled on a notepad

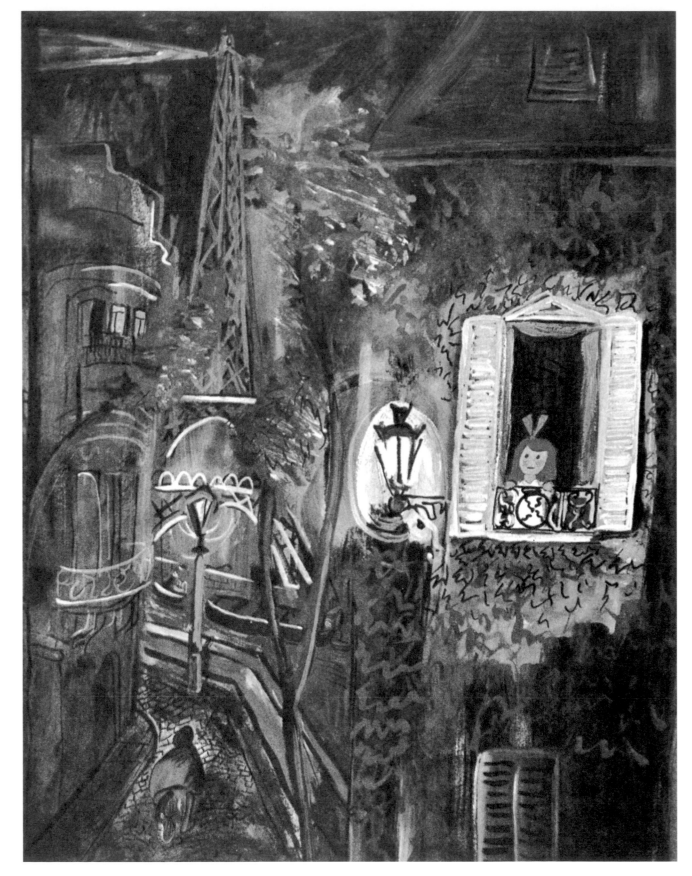

"Oh, Genevieve, where can you be?"
—*From* Madeline's Rescue.

In 1951, *Good Housekeeping* published a new story entitled "Madeline's Rescue," which marked the return of Bemelmans' most famous character. Bemelmans spent years working on his sequel to *Madeline* in what was to become his standard method: laying out the plot, making thousands of rough sketches, writing the verse in pieces, making dummy copy after dummy copy of the entire book, then producing a test version for a magazine, which would finally be redone in book form.

In an April 1952 letter to Derek Vershoyle, his agent in Europe, Bemelmans made plain that his return to Madeline was not a one-shot deal:

> *The continuity of the books stood as follows [last meeting]:*
> > *Madeline*
> > *Madeline's Rescue*
> > *Madeline and the Bad Hat*
> > *Madeline and the Arab*
> > *Madeline and the Castle Number Nine.*
> *Since our last meeting I have been thinking about London, and I might put that ahead of all others after Rescue as it seems a very natural Idea. The Reason is simple—I have the story: The Committee of the School asks Miss Clavel what she wants as a gift for her anniversary, for years of devotion to the little girls. She says she would like nothing better than to show them her native city and so they are taken to London, and Miss Clavel acts as a guide, we do the book's tour of London. It ought to be good and amusing.*

The Viking Press rectified its earlier mistake and published *Madeline's Rescue,* also buying the rights to *Madeline* from Simon and Schuster. Bemelmans was reunited with May Massee, although their relationship was different. Bemelmans, now an established writer and artist, was on a more equal footing with Massee, a change reflected in their correspondence.

Dear Ludwig:

I just came back today to find your letter of the 14th, and I'm just overcome at the idea of choosing one of these marvelous MADELINE pictures! I do think they are the most beautiful things you have ever done.

Now I want you to think about Cucu Face and Fleabag. Those are the two words that bother me in the MADELINE manuscript. Enough of Hound is fun and has a quirk to it that is all your own, but Cucu Face and Fleabag don't compare in any way with those pictures, which are as amusing as they can be and as beautiful as they can be. There's not one cheap line in those drawings, but I think the Cucu Face and Fleabag are just cheap—as if they were lifted from the comics, and not good comics.

I know you want contrast, but if you could possibly think of other names for Cucu Face and Fleabag, your book would be all of a piece, text and pictures. I know you got away with it all right in a magazine, but the magazine isn't as important as the book. You can get away with it in a play, where they are just spoken. But when you see them day after day after day in a book, they're just tiresome.

It's up to you. I couldn't replace them. It's something that has to come out of you, and I know you can do it if you want to. I just want to make you want to.

More than a thousand thanks for your generosity.

Love from

[signed "May"]

Fleabag became Genevieve, but Cucuface stayed.

Bemelmans did his best to make the new Madeline book an event. For *Collier's* he sent the girls to witness the elevation of Princess Elizabeth to Queen of England in "Madeline at the Coronation," published to coincide with the release of *Madeline's Rescue*. The book was an immediate success, winning high sales and the Caldecott Medal for best picture book of the year.

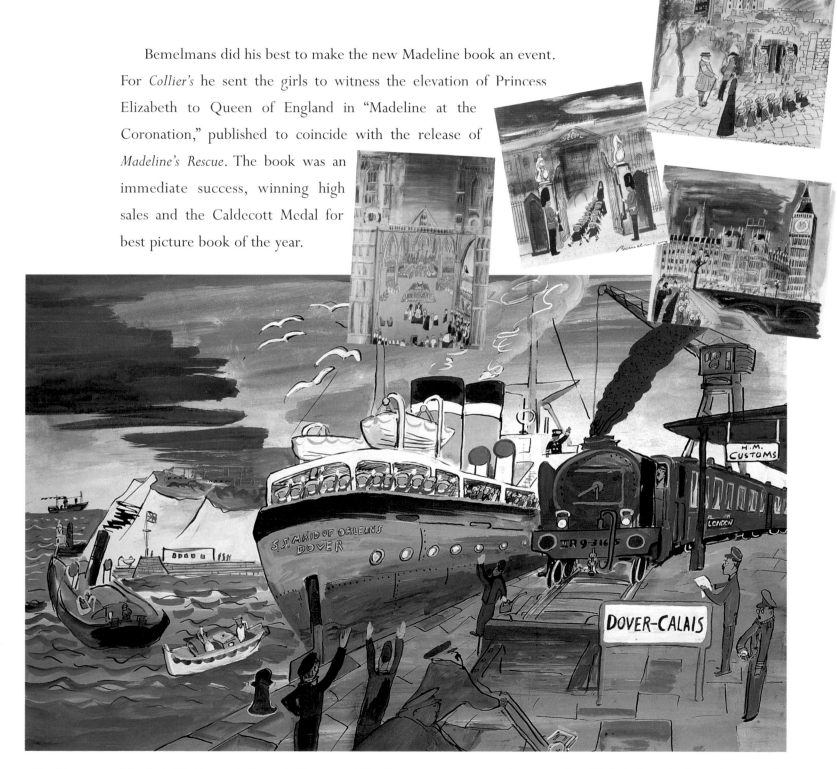

The girls tour around London in "Madeline at the Coronation" (top pictures); The illustrations were accompanied by verses such as, "We had cakes and cookies and pastries and tea, / And we took a train and went to sea," for the painting of the girls returning to France aboard the ferry (above).

"In every place they called her name."

On Receiving an Award

Ludwig Bemelmans reflects upon his winning of the 1954 Caldecott Medal in this excerpt from an unpublished essay.

The Caldecott medal, which was given me for Madeline's Rescue, *is the first award I have received in my life.*

The announcement of the award filled me with apprehension. It would be extremely painful to me to step up and be presented with anything, and to listen to the words of praise said on such occasions would make me physically ill. It all dates back to childhood—being the champion left backer and the last boy in class I developed a kind of pride in my position at the end of the line. So much so, that some brewery money my grandfather left me in Bavaria, I have placed in a trust fund which pays annually a sum of money to the boy with the lowest marks in the school that I attended there.

I have in mind extending this prize to a dozen boys, and to go there and have our own graduation exercises, and after, a very fine sausage and kraut fest on the banks of the Danube with beer. Now being myself a donor of an annual award, the Ludwig Bemelmans Foundation for the Inept, I am content to stay as I am. I rather give than receive anyway.

I must also add a word of consolation to parents here; my prize winners all have made out better and are happier than those at the other end of the class. I have therefore asked Madeleine, my wife—who is extremely photogenic, and the exact opposite of me, the holder of citations, medals, and even a doctorate—to accept the award for Madeline's Rescue, *on my behalf. Curious and marvelous about this award is that it was given to me at all.*

Bemelmans followed his successful return to Madeline with a very differ-
ent kind of book, a novel for children entitled *The High World*. The forty-
six black and white drawings in *The High World* showed that Bemelmans
had mastered the medium of pen and ink. But Bemelmans found this
medium, and in fact all the media he was working in, limiting.

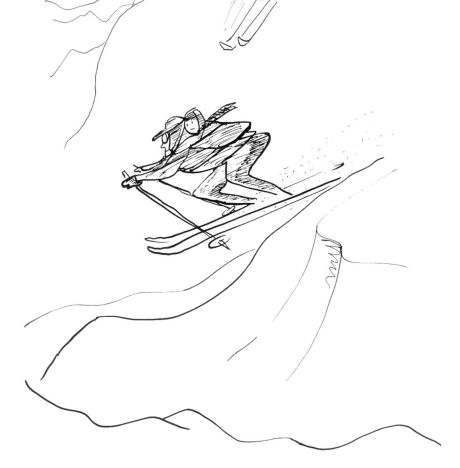

The climax of The High
World *involves a thrilling
ski rescue, rendered over
seven wordless pages.*

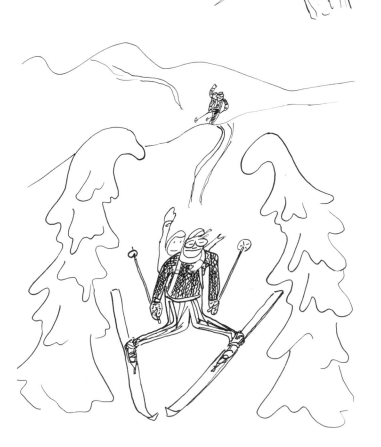

Bemelmans had always painted "pictures with a purpose"—that is, illustrations to be published in books or magazines. His color pictures were done in gouache, a kind of fast-drying watercolor favored by graphic artists. But in the summer of 1953 on a trip to Campobello, Canada, Bemelmans began to experiment with oil paints and to paint for the sake of painting itself. In *My Life in Art*, he explained:

> *I started to hide away in places and paint, and then found that there were things one cannot render in black and white, in line, with pencil, or pen and ink, water color or gouache, and that they had to be painted in oil. Or I should say, perhaps, that I could not render them in these media to conform with the image that was in my eye, or what I wanted the picture to be. This is an agonizing period for an artist; one might as well have stumps for arms—it is impossible to reach for the brush and to paint. There is the image, and beyond reach.*

The next four years would be a trying time for Bemelmans, as he attempted to overcome his life long fear of—and impatience with—oil painting.

A pair of oil paintings from Campobello, circa 1955.

Turning to France for inspiration, Bemelmans purchased a rundown building in Paris near Notre Dame which he planned to renovate and use as a painting studio and home. The bottom floor had housed a bistro for *clochards*, a French term for people living on the street. Bemelmans took the restaurant upscale, reopening it with the name La Colombe in April 1954 to great fanfare. However, the renovations proved to be financially ruinous due to the costs of complying with the many rigid regulations prescribed by French law. Worse, they had been time-consuming and distracted him from painting.

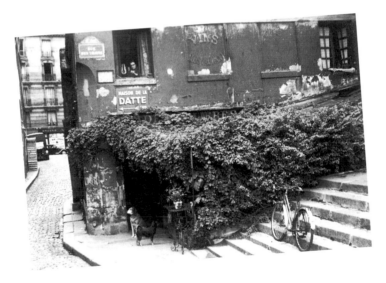

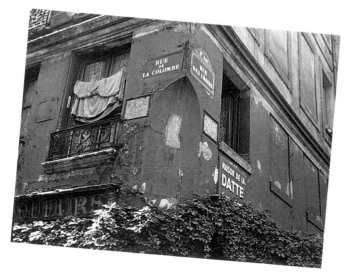

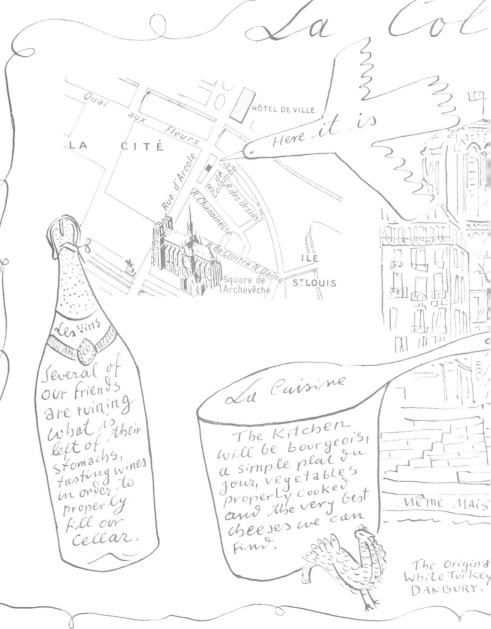

Bemelmans' opening announcement for La Colombe, surrounded by photos of the bistro and the murals Bemelmans painted there.

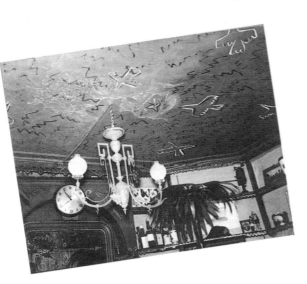

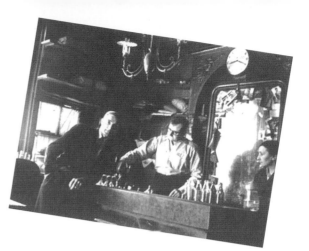

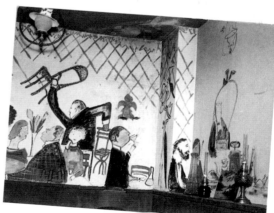

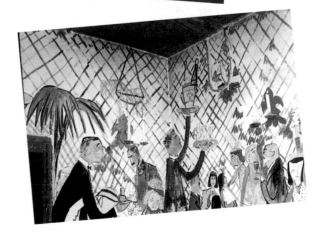

nbe

Music ♪

A little Night music every evening until dawn

La Colombe
ANCIEN
HOTEL
PARTICULIER
DE LA
BELLE
FERRONIERE
MAITRESSE
DE FRANÇOIS
PREMIER
CONSTRUIT
EN 1225
Numero 4
RUE DE LA CO-
LOMBE
PARIS IV
ISLE DE LA CITÉ

Private Dining Room.

Bemelmans

Postgasthof Lech am Arlberg AUSTRIA

The Hotels Flexen and Lorünser, Zürrs am Arlberg.

Bemelmans refocused, and simplified his life. He sold La Colombe, and with it, the only building he would ever own. Then, in 1957, he rented a studio outside of Paris in Ville D'Avray and gave himself over completely to his new pursuit, painting in oils. But he was still tentative; Bemelmans burned dozens of his first attempts. But finally a friend named Salinas who was a painter suggested an experiment that helped Bemelmans find his way.

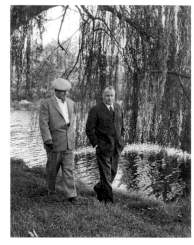

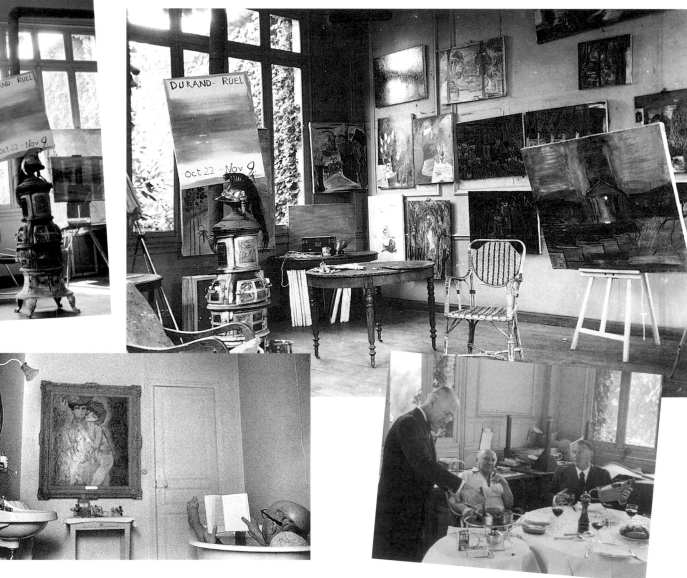

Views of Bemelmans' Ville D'Avray studio: Walking the grounds with Armand de la Rouchefoucauld (top); works in progress (center and center left); Bemelmans reading in the tub, where he also liked to write (right); A catered lunch with Armand in the studio (far right).

Bemelmans later recounted:

I had a picture of the harbor of Les Sables-d'Olonne in front of me, which I had painted in gouache, and he asked me to copy the picture. To my great surprise, the picture was there in oil. This was a moment of great liberation.

Bemelmans' cloud of frustration began to lift, and his work flowed.

The famous stripper Dodo D'Hambourg poses fully clothed for a series of nude paintings (photos at left); Three drawings of the patrons and performers of the Crazy Horse in Paris that Bemelmans sketched for the background of the Dodo series; A drawing of the front door of Bemelmans' studio (bottom right).

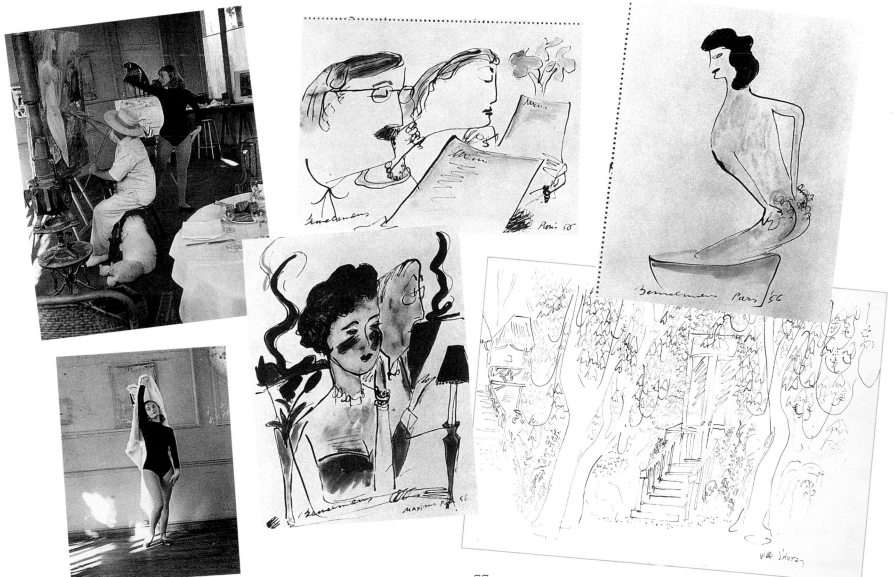

The French Paintings

In 1957, Bemelmans had his first major show of oil paintings, at the Durand-Ruel gallery in Paris. *My Life in Art* was published the following year. The book featured full-page color reproductions of his canvases, some of which are shown on the following pages.

In *My Life in Art*, Bemelmans documented how he transformed himself from an illustrator to painter. His two pictures of Les Sables-d'Olonne, described but not shown in his book, appear in gouache below right and in oil on the opposite page. All the paintings in this section are of the towns and cities of France.

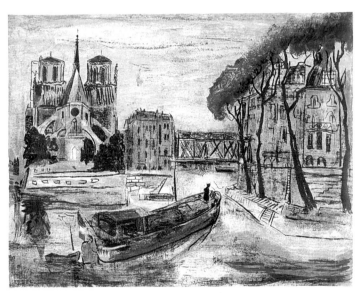

A poster for the exhibit.

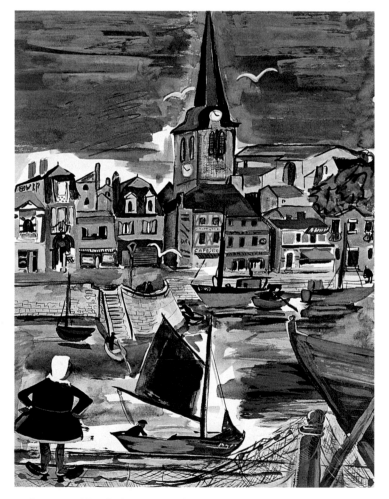

Harbor, Les Sables-d'Olonne. *Gouache, 1948.*

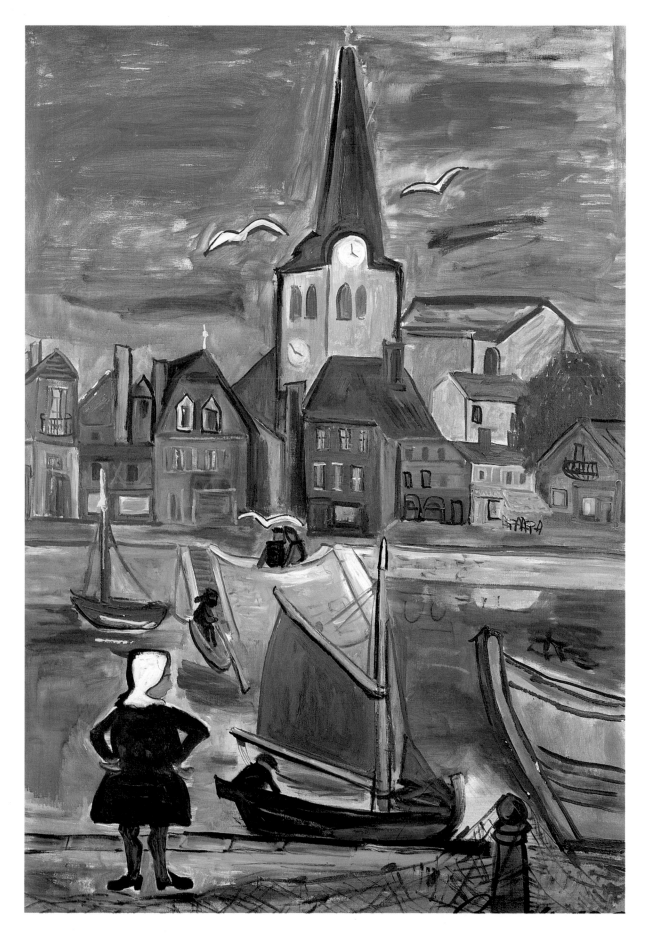

Harbor, Les Sables-
d'Olonne. *Oil,
1957.*

Couple Eating
Écrevisses,
Maxim's, Paris.
Oil, 1958.

Outdoor Cafe. *Oil, circa 1957.*

I am a painter, and with a box of colors and the immediacy of design, one can tell a story easier and quicker than with black ribbon in a typewriter.

—From "The Hotel Splendide–Revisited," Town & Country

Nuns Returning from Market, Les Halles, Paris. *Oil, 1957.*

*I*m *going to a peculiar hell every day in painting . . . it's to eliminate facility and be primitive and direct . . .*

 —From a letter to his wife dated May 28, 1957

"Le Vert-Galant"
Seen from Below,
Paris, *Oil, 1957.*

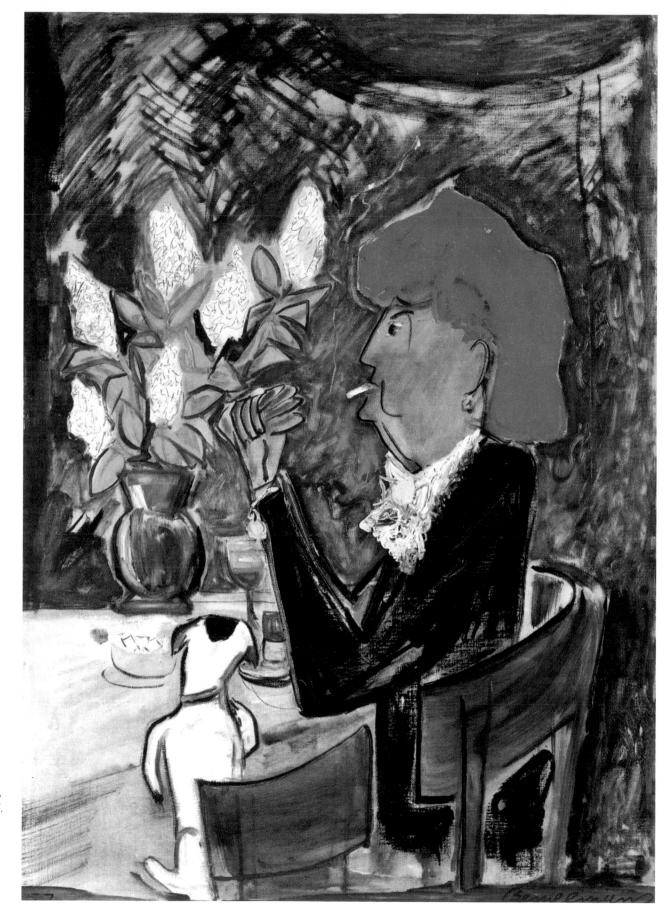

Red-haired
Woman and Dog,
Ville d'Avray. *Oil,
1957.*

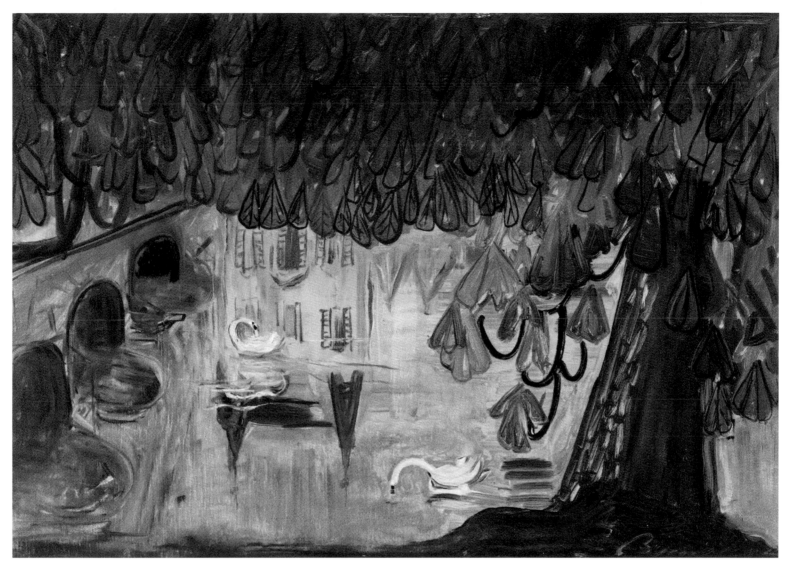

Swans and Chestnut Trees, Ville d'Avray. *Oil, 1957.*

*N*ew *Years Resolutions: No more interviews. No more television. No more radio. No more film. No acceptance of decorations including the Legion D'Honneur. No playwriting. No filmwriting and no collaboration on anything. No contact with publishers except via mail or agent. Nothing that interferes with painting.*

—From notes dated December 1, 1958

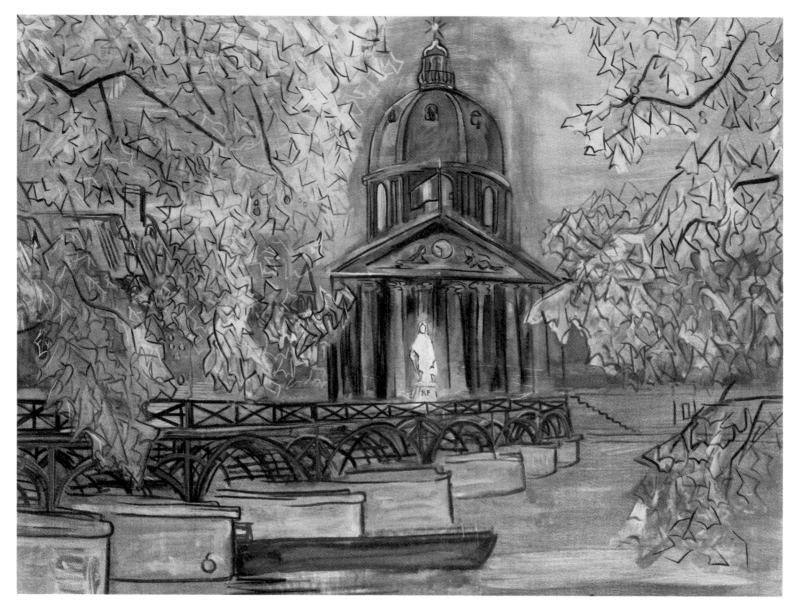

Pont des Art and Institut de France, Paris. *Oil, 1957.*

*W*hile I look at an object for a long time, and make many sketches and go back and look again and again, when finally I paint it is done in a kind of urgent fury. It goes quickly or not at all.

—From My Life in Art

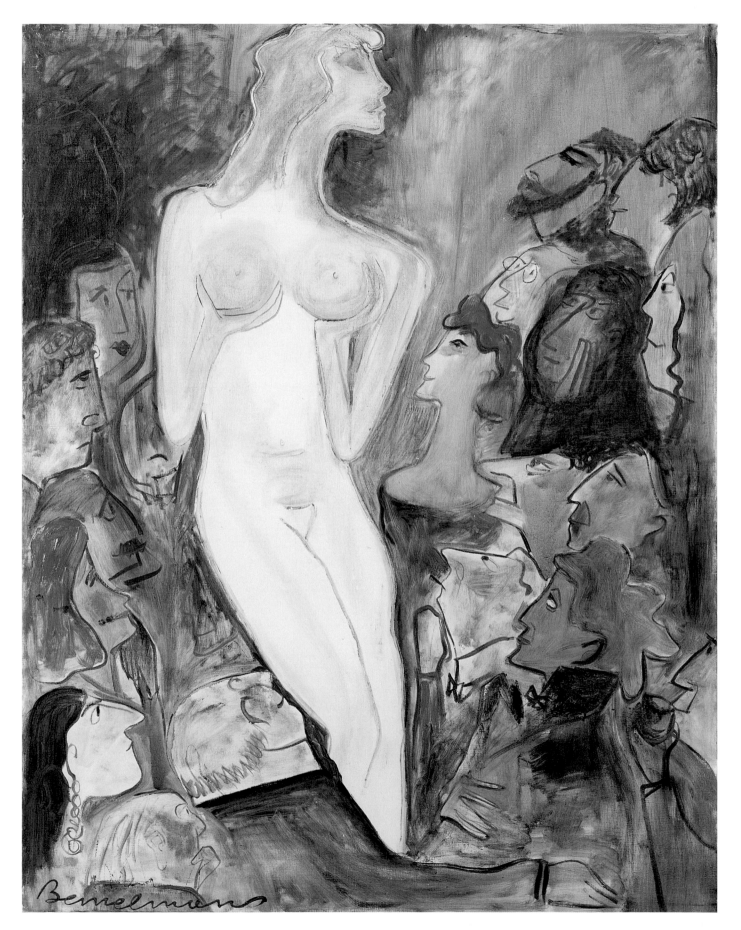

Dodo
D'Hambourg,
Crazy Horse
Saloon, Paris.
Oil, 1957.

Bemelmans Junk

BY VICTOR HAMMER

Although Bemelmans spent a great deal of time in France, his home was still New York. In 1955, Hammer Galleries, which was on Fifty-Seventh Street, mounted an exhibition of Bemelmans' work, the first in what became an annual event. The gallery was operated by Bemelmans' friend Victor Hammer, the brother of Armand.

In the following essay, Bemelmans pretended he was Victor writing about Bemelmans. The piece was published in a slightly revised form as "La Casserole à la Bemelmans," in *Town & Country*, January 1956.

We have all kinds of curious people come to the Hammer Galleries—one of the oddest is Ludwig Bemelmans. Over a period of years, he would come in, browse around among Romanoff icons and Imperial Easter eggs, then go to the vitrines that contained jewels. His favorites were emeralds and rubies. He studied them and then made his selections carefully, and always in good taste—nothing ostentatious. He picked things in the medium-price class, authentic and ancient, costing a few hundred dollars. Then he wrote cards with "Happy Birthday," "Happy Anniversary," "Happy Name Day," and had us send the things to his wife.

The first curious thing about it was, since he was an artist, we never expected him to make these purchases, and secondly, we thought it would be a matter of months before we'd get our money. But we were paid with meticulous promptness. The third and most curious circumstance was that a week or so after they were delivered the gifts were sent back by Madame Bemelmans with a request for a refund. Naturally we complied. This continued for a period of some ten years, and might have gone on forever, since by now everybody was used to the routine.

It all changed one day last June, when Bemelmans came in as usual, wandered from one object to the other, and finally stopped to look at a walking stick made for Czar

Alexander III, of Russia, by his court jeweler Fabergé. This cane is magnificently mounted in two kinds of gold with a handle of jade. Bemelmans asked the price and bought it for fifteen hundred dollars.

The Czar Alexander III was a very tall man, and for Bemelmans it had to be cut down two inches. When this was done, I decided that here was a chance to see him at home and make the acquaintance of the woman who doesn't like jewelry. So I decided to deliver the cane myself.

Bemelmans with his dog Bosy.

They were sitting in front of a large fireplace in a studio with a forty foot ceiling. At Bemelmans' side was a huge black dog like the hound of the Baskervilles, with red eyes. He regarded me in bored silence. At the side of Madame was a Yorkshire terrier which I thought was a ball of yarn until it yapped.

There was a wonderful smell in the room. "It's from the logs," said Bemelmans, "I love to burn lignum vitae. I get all the output of a factory that makes bowling balls, that

Bemelmans and Mimi with their dog Kitty.

is, all the waste wood. The only trouble is, it's very hard to get it to start burning." He pointed at a packing case next to the fireplace that was filled with paper—good paper and pieces of board. He took a piece of paper and rumpled it to put under the logs.

I took it away from him just in time. "Haven't you ever heard of kindling?" I asked him. "You're burning currency."

"That's only junk," he replied. "I clean out this stuff every six months or so. I sketch and paint all the time—just the way a musician has to rehearse. For a finished picture I make hundreds of sketches sometimes. For instance, that piece you have there is a preliminary sketch from the next children's book, the third in the Madeline series, called The Bad Hat. It's the sketch for a Spanish cook who appears in the book."

I had straightened out the crumpled piece of paper and I pushed the cardboard packing box away from the fire. "There are people who'd love to own these drawings," I told him. I pulled out more of them. As all are quick sketches, they were spontaneous,

filled with life. They were on the backs of envelopes, old menus, fragments of letter paper, and each was filled with vivid design and some with color.

The next day I sorted the stuff I had saved and taken with me in a carton—the stuff Bemelmans refers to as the "junk." "Maybe I'm crazy," I said to myself, "and maybe he's right to burn it. But let's see." I took two of the small drawings and put them in the window of the gallery. At the time there were a Fragonard and a Bouguereau there. In half an hour the Bemelmans were gone. A clerk and a stenographer in a nearby building had come in and bought them. I placed two more in the window, together with a small sign reading "Bemelmans' drawings and sketches for sale." The Galleries were soon filled with customers. Every drawing and sketch was sold and dozens of people were turned away disappointed. In my experience the only comparable interest was aroused when my brother Armand and I cut up dozens of sketchbooks of the great eighteenth-century painter Turner and sold them at popular prices, together with the fifty-million-dollar Hearst Collection. At that time, we had to call the police to prevent a riot among the pushing crowd of would-be purchasers. People who normally don't come into our galleries now buy Bemelmans' drawings and sketches and it is a curious thing to watch them make their selections. A quiet smile is on their faces. They are happy looking at them.

When we first asked Bemelmans what he wanted for them, Bemelmans said, "Oh, anything—give them away. Five or ten bucks, if you must charge for them."

With the casual buyer came the collectors for the larger, more valuable pieces, and even these started to run out. I hung around Bemelmans like a detective, seeing to it that he didn't throw out anything. I even ate with him because he always draws on the backs of menus.

One day he said, "I've supported myself by writing, which I loathe. Anyway my writing is nothing but painting—instead of line and colors, I use words. And it takes a thousand of them to say what you can in a few lines with the stroke of a brush. I've always avoided patrons and gone my solitary way. I never knew whether it was any good

91

or not. I am beginning to believe that maybe now I can do what I have always wanted to—paint, do nothing but paint, for that gives me pleasure."

We were friends by now. He eats at Le Pavillon, which he claims is the only restaurant in New York. As we sat there one day, he said, "Before we're dead, before the bulldozers and Mr. William A. Zeckendorf remove from America all that is old and beautiful, I would like to paint it—the quiet streets, the silent corners, the beauty of small towns. But I need a bridge to lead me into it. I have to start somewhere. I will finish with New York, but I don't know where I want to start. I need an island. I've been to Nantucket, but there you fall over an easel every step you take. It's become arty and typical with souvenir art. I need a place that has privacy."

I told him then that I knew an island, remote, unvisited, at the easternmost part of the United States. Here I have spent some summers and here we have a house. Ludwig installed himself there, and he started to paint after walking about for a week. We now have pictures on exhibition of this island of Campobello. Previously, his canvases were mostly of Europe. He had concentrated on France, Italy, and Spain.

Bemelmans is leaving for London, Paris, and Vienna now. On his return he will start out with a car and a rolling studio; with a humidor, a wine bin, and a kitchen that will be stocked by his Pavillon friend, Henri Soulé. The trek will start through America from one town to another. And as Audubon did the vanishing birds, he will paint the vanishing idyll, the old streets, the houses at the end of a lane, and make a nostalgic album of America, the country he loves best. It should make a magnificent volume, a fine collector's item.

I will travel along to look for scenery, to enjoy the wine and the cooking, but mostly to see that Bemelmans doesn't light any fires with his drawings and sketches.

Oh yes—the jewels of his wife, Mimi—now that we are well acquainted I can ask that question.

$ 100.-

Bemelmans and his "rolling studio," observed by a passerby.

"Mimi is crazy," said Ludwig, "but the ideal wife. She dislikes furs, and jewelry bores her. The stones are cold, the gold is heavy and you have to insure it."

"But what happens then?"

"She always exchanges it for cash, and the cash goes to various societies—for humane slaughter, for cat and dog shelters. Mimi is animal crazy and a vegetarian; but Kitty, her small dog, eats at least two oxen a year. She can explain that somehow, as making sense; she's a Doctor of Philosophy. Ask her sometime; it takes three hours, and to me it makes no sense. Also I can't rhyme the fact that she cooks, excellently, for me, the best viands. It all goes under the heading of woman."

As he said this, he drew several casseroles, that are herewith reproduced and are for sale at the reasonable prices marked on them.

$ 50.-

Bemelmans' main publishers were based in New York, and it was there that he did most of the work on his books. But he would grow restless with a regular schedule and get the urge to travel. After Barbara went off to college in 1954 his most frequent traveling companion was his wife, Mimi. They would go stay with friends, often in the Northeastern part of the United States.

Parsley was set in New England. Unlike the Madeline books, which were vertical, with many line drawings and text on every page, this new book was wide and filled with full-page paintings accompanied by rhymeless poetry. If *Madeline* was a storybook, *Parsley* was an art book.

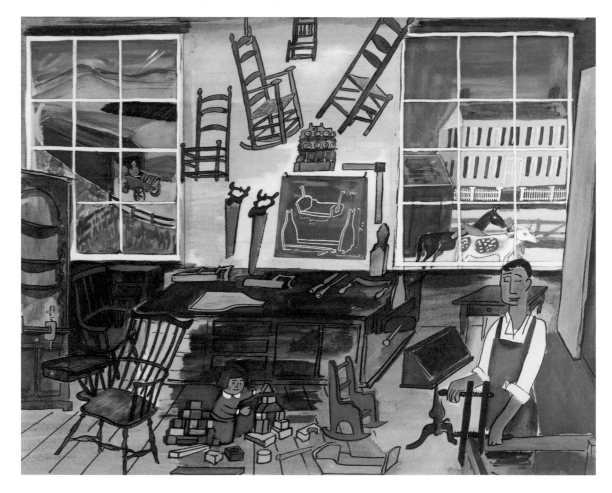

In many ways Parsley was a book for Bemelmans' wife, Mimi, an animal rights activist. The hunter as villain, the animal as innocent, and the tree as hero, were themes that appealed to her; The hunter was modeled on Ernest Hemingway.

While working in this new style, Bemelmans also found himself working with a new editor, Harper's Ursula Nordstrom—the innovative editor of such classics as *Good Night Moon* and *Where the Wild Things Are.* Bemelmans would go on to do two other books with Nordstrom, *Welcome Home!* and *Marina,* his final book, but he would continue to work with May Massee at the Viking Press on the Madeline sequels.

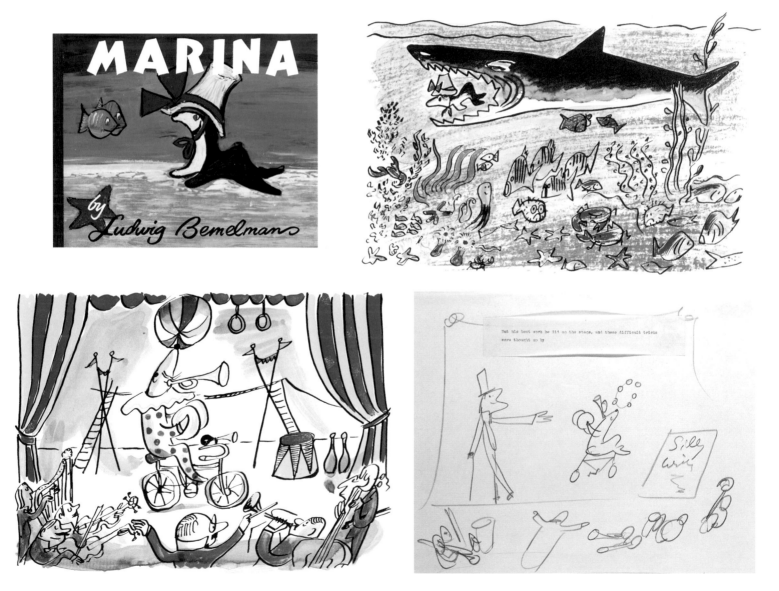

Marina was about the Great O'Neil, an old performing seal in need of a vacation, which he takes in Florida with his wife and daughter. He resembled Bemelmans' young seal, Silly Willy, star of the mid-1930s comic strip and a never-completed children's book (bottom right).

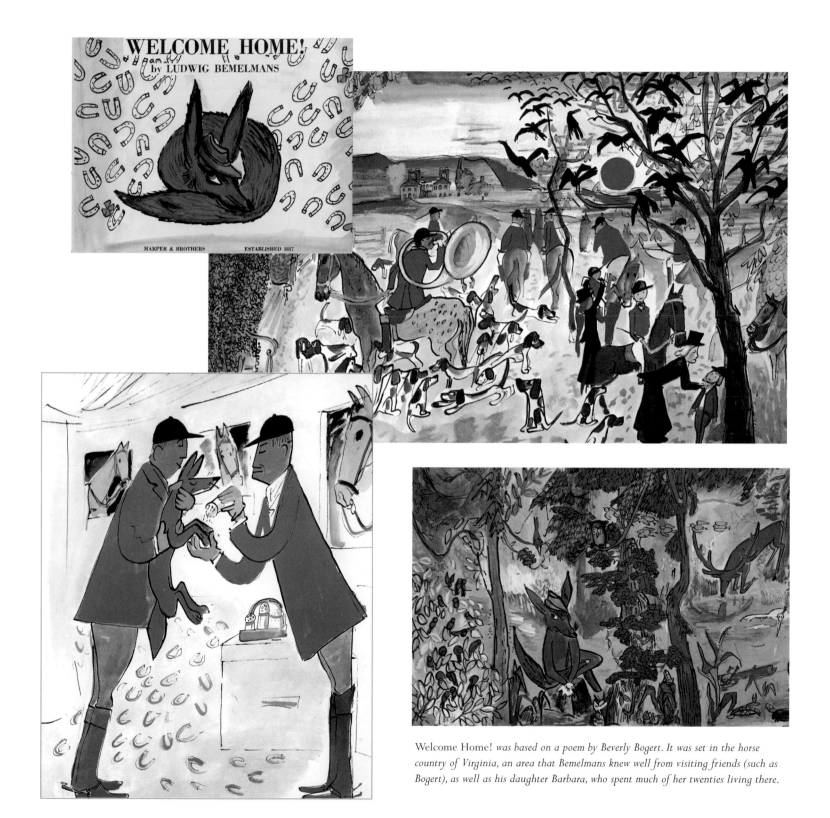

Welcome Home! *was based on a poem by Beverly Bogert. It was set in the horse country of Virginia, an area that Bemelmans knew well from visiting friends (such as Bogert), as well as his daughter Barbara, who spent much of her twenties living there.*

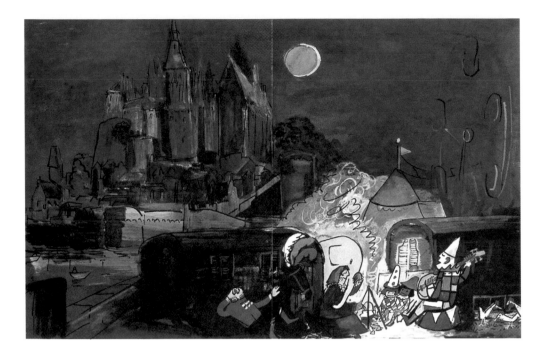

Bemelmans recognized that Madeline would be his legacy, and in the last years of his life worked at a feverish pace to build the series as he had laid it out in the early 1950s. *Madeline and the Bad Hat, Madeline and the Gypsies,* and *Madeline in London* were published in 1956, 1958, and 1961 respectively. These books demonstrated his heightened understanding and feel for painting, and each one in turn showcases these talents more.

"And never—never—to go to sleep," from Madeline and the Gypsies *(top right); "And so are the people—on ship . . . and shore," from* Madeline in London *(near right); "He was sure and quick on ice," from* Madeline and the Bad Hat *(far right).*

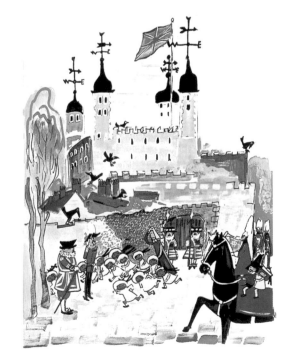

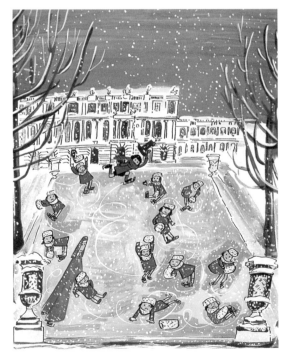

But during this period, it was the increasing recognition that his individual canvases received that provided Bemelmans with his greatest satisfaction. In 1959, the Museum of the City of New York organized an exhibition of Bemelmans' paintings of Manhattan and its environs. These pictures were the most abstract, painterly ones Bemelmans ever produced.

Unlike that of so many artists, the power of Bemelmans' painting was not on the decline in the last years of his life. Tragically, he seemed to be just reaching the moment that every painter dreams of, when his art becomes clear and pure. Bemelmans was finally striking the appropriate balance between the primitive and the refined that he had been seeking, with an absence of sentimentality or cartoonishness or melodrama, a painting of honesty and power.

An invitation to the opening of the Museum of the City of New York exhibition (above left); The big event was heralded by the appearance of Bemelmans' paintings on magazine covers (center and right).

The New York Paintings

The paintings in the following section are from Bemelmans' only museum exhibition. Although he had painted New York before, Bemelmans was still intimidated by its scale. He eventually conquered his fear, although he began in a way he described as "ridiculous." In his first effort for the exhibition, he hid the city behind a bunch of flowers (below right). And then:

> *The next evasion of the subject is a painting of the Statue of Liberty, which I again concealed behind familiar things: I painted the cashier of a French restaurant, with the chef, and two cats, and at the background of the composition I put a postcard showing Our Lady of Liberty (opposite page).*

Finally Bemelmans stopped worrying and just enjoyed the act of painting. He worked in a flurry completing a picture a day until he had fifty of them.

A poster for the exhibit (near right); Gramercy Park, Elevated. *Oil, 1959 (far right).*

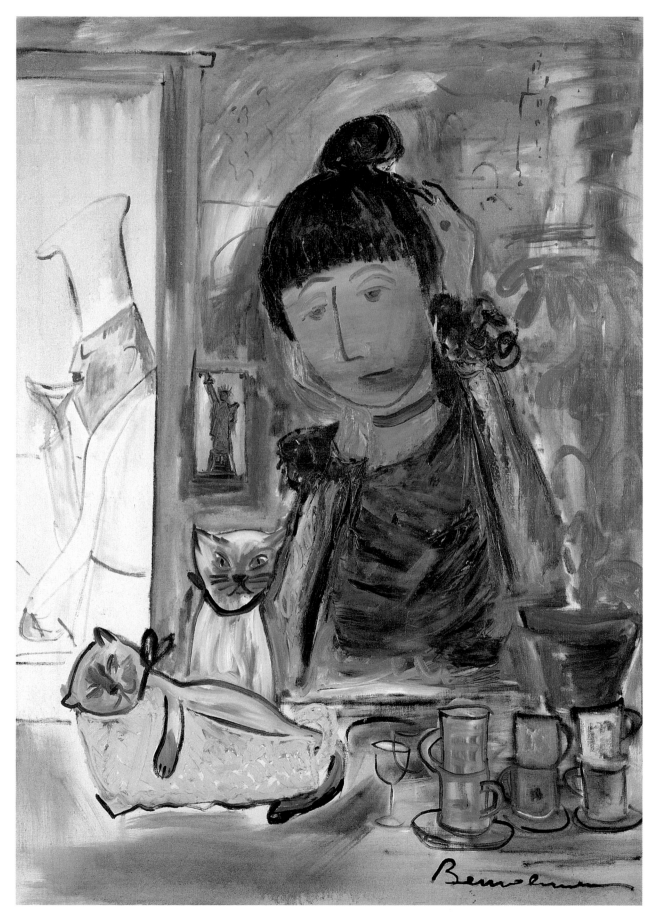

French Restaurant
with Cats. *Oil, 1959.*

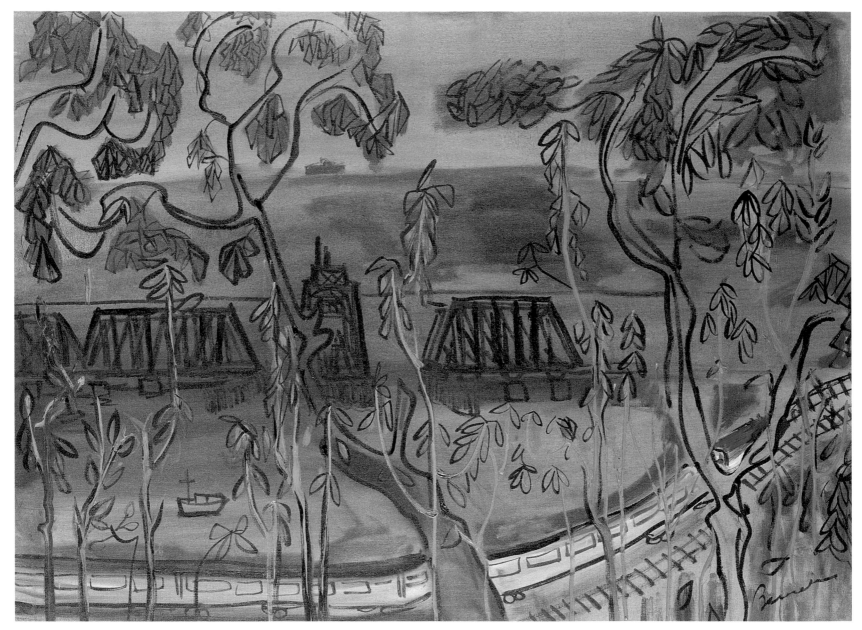

Spuyten Duyvil Bridge. *Oil, 1959.*

*T*hese horse-drawn vehicles may be seen in any New York neighborhood—huge moving bouquets that usually come from Long Island, where the flowers are grown. On the right you see a dome which I took license to put there; it is the old World Building, and it no longer exists. Years ago I sat under this cupola drawing a comic strip (opposite page).

—*From "Bemelmans Paints New York,"* Holiday, October 1959.

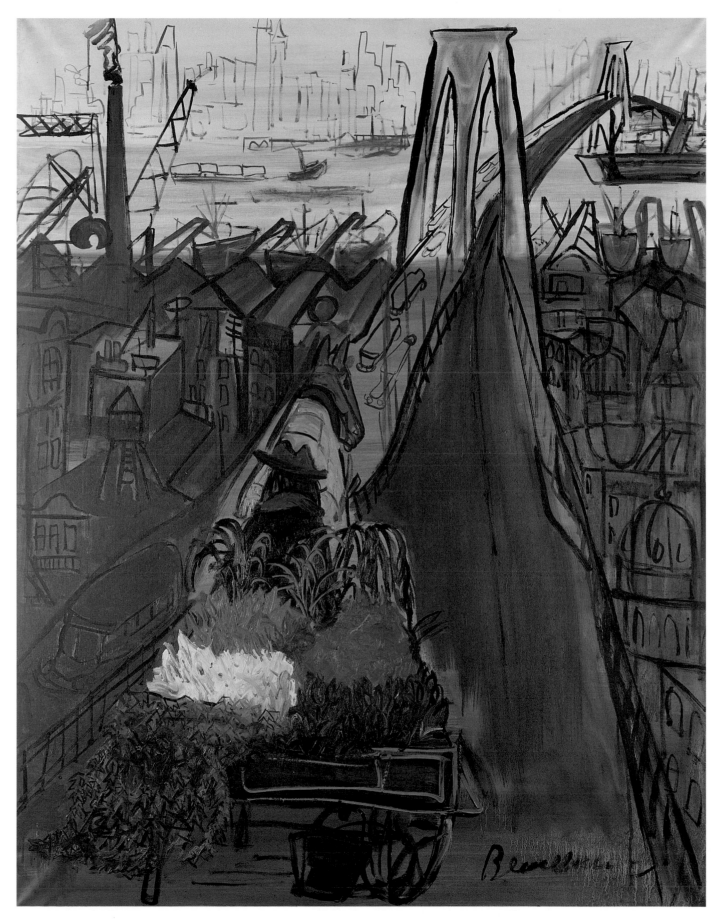

Flower Wagon
on Brooklyn
Bridge. *Oil,
1959.*

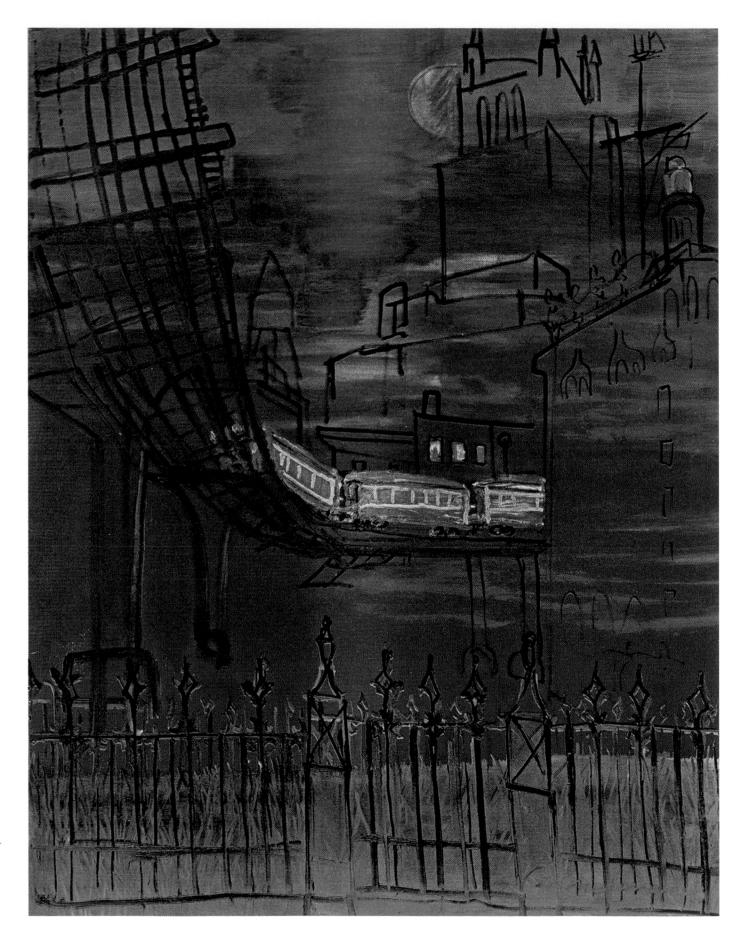

Seaman's
Institute.
Oil, 1959.

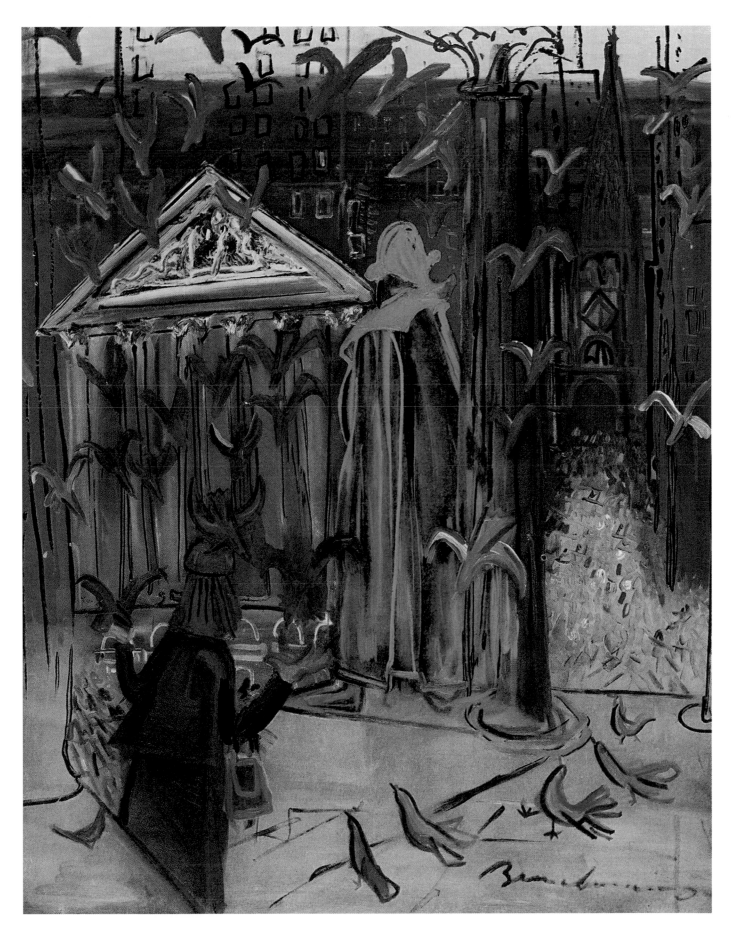

Wall Street.
Oil, 1959.

The Empire State Building Seen from the Jersey Flats. *Oil, 1959.*

*T*ake *the view of a bridge in the Jersey Meadow—I was always fascinated by the colors that play in the Jersey Meadow, the flames the violets and the night sinking down as if an ocean of dye indigo flooded it—for a while as the sun sinks—objects fight it—construction bridges—road bridges— the last reflected sky and then it dies—in black night.*

—Scribbled on a notepad, c. 1959

The Empire
State Building
Seen from the
Jersey Flats,
detail.

Although painting had become the focus of Bemelmans' life, and children's books had once again become his anchor, there were certain ideas he could express only in his writing for adults. In the last dozen years of his life, he produced nine novels and books of semiautobiographical fiction.

The Woman of My Life

This book, published in 1957, was loosely based on the life of Bemelmans' friend Armand de la Rouchefoucauld. The narrator tells of a series of woman, each of whom he believed was the woman of his life. The novel begins and ends with the woman who is his true love, the one who landed him in the jail from which he writes. She is Evelyn, whose name is the title of the first chapter; it begins with the following:

I cannot read,

I cannot think,

I cannot write.

I cannot remain seated or standing. I walk to the window, to the door, to the telephone. I have it badly, the vague malaise that is love.

She is late. Ignoble thought that she might be with someone else. I laugh, but briefly.

When you fall in love, when people like me fall in love, you give away your person to the other, and when the other leaves, she takes you with her, and there remains only a shell, with her shadow, her scent, the echo of her voice, to set it in painful vibration.

In the eyes of dogs, one sees the sorrow of abandonment most clearly. I look in the mirror—yes, just like a dog, a particularly melancholy one, one of the race of long-sighing big dogs, a Briard, a Bouvier, a Labrador retriever with his head between his paws looking up from the floor, mortally fearful that at any moment the most terrible thing in his life will happen again, that he will again be abandoned to lonesomeness. I cannot be alone, I cannot live without love.

She is beautiful—but love is something else:

Amour, plus que beauté me touche

O ma chérie, et j'aime mieux

Bien mieux ton regard que tes yeux

Et ton sourire que ta bouche.

Yes, I am more in love with the look in her eyes than with the eyes themselves, more with the smile than with the lips.

She is changing my life. . . .

On the Ego in Writing

This stream-of-consciousness essay in which Bemelmans reflects on the nature of writing has not been previously published. It is from the early 1960s.

When writing, one writes mainly about oneself, for the pen is held by the writer. The same is true in other forms of expression, for instance in painting—if you know the artist, you will see him always in his pictures, even if they be landscapes. The more definite the personality the more the identification. Goya is, Picasso is, Dali is, Renoir, Van Gogh—in writing it is less evident for writing is a projection beyond the immediately visible.

Putting down words on paper is a terrible, painful process. It is a search for words, for form, for telling a story in images that you cannot draw like a child but must project.

The projection must always be (this is my personal conviction) an exaggeration, to be true to life. An exaggeration of the usual fact as it exists, either in your mind or in nature. I am without imagination. I can invent only from the model—I have a potato in front of me—and I can make it sprout, with some work and turn the sprouts into lilies or thistles. But I have to have the potato and the Idea.

For this I sometimes keep an Idea, taken from life, or the newspaper, or having been possessed with an Idea or by an Idea for a long time—and then feed material into it. This basic potato then begins to shoot its sprouts upward and it finds itself either in a cellar where its sprouting will be pale and thin and ghostly, or it is in rich earth and breaks out into a cultivated garden and is surrounded by flowers, visited by butterflies and covered by a cloudless sky.

The cellar potatoes are the themes of my adult books. The garden variety, my children's books, and sometimes there is a happy crossing.

I depend a great deal on notes. I write a journal, a curious one, for it is a messy

mixture of things experienced, of things imagined, of things put down that have never happened, but read as if they had, for as I go along, I play with the matter—and write some of it as fiction, that is the dullness of actuality bores me, and I superimpose that which I would make out of a situation while it is alive.

So there are then in the writing of this, fact—the use of fact as it has suggested itself to me while it happened and which in order to avoid writing it over three times, is a half cooked scenario with the exaggerations. How good these things are (again, only for me in this instance) is that when I lose part of such a composition—I suffer anguish and even pray, to find it—for it is impossible to reinvent, to do it over (at least for me it is). I had such a fictionalized passage about Ireland written, and by mistake burned it. I cannot do it over again—it was absolute-

ly right and good and is lost forever. I have tried to reconstruct it, but there is this which is written in a place, with people about you, with your imagination working in that climate, in that moment, in that house in that mood, that is not going to come again, it all hangs on detail, true or imagined, and the imagined so much more than the true. For the subconscious mind's contribution is great, you work the stream of consciousness into the composition, mostly it writes itself. As for inspiration, it comes with intensely hard work—Yes then it descends, but never out of the blue. When you drag yourself to the writing table and suffer a good long while, then suddenly the drab brown potato starts to sprout. Sweet potatoes sometimes sprout easier than the Irish variety.

When I turn to look out
of my window . . .

One novel, *The People of Regensburg,* remained unfinished. In an introductory note dated "Munich, April 1962," Bemelmans wrote it would be "a book on childhood in long perspective. It is the story of two brothers—one who loved Regensburg—my brother, and who died of lonesomeness of it and love for a Jewish girl. And of me who hated it—to this day. I think it will be done very quickly for it has been in my mind for my lifetime." The events of his youth were fresh and still bitter. Bemelmans' gift for communicating to children was largely due to how closely he held his own childhood.

Bemelmans left Munich for Regensburg to check on his brother Oscar's grave, which he had heard was in disrepair. It was not. On his way back, Bemelmans' car passed over the railroad bridge, and he saw Regensburg for the last time:

> *The unchanged railroad station—sad and heartless—Here I left for Rothenburg to be put into a Pensionat—Here I left for my Uncle's hotels in Tirol when I was thrown out of the Pensionat—Here I returned when I was thrown out of the hotels. Here I left for America.*
>
> *Here I returned with my brother to bury him—and stayed a day.*
>
> *Here is my Fate in these rails—my escape.*

Bemelmans had been sick for nearly a year when he made his trip to Munich. He barely looked like himself, having lost a frightening amount of weight. He was diagnosed with hepatitis, but surgery would show that he had pancreatic cancer. His family thought it best for him not to know. He remained active and continued to work as he always had, writing, painting, and planning for the future. On the night of October 1, 1962, after a dinner sent up by Lüchow's, Bemelmans died in his sleep. In accordance with his wishes, he received a military burial at Arlington, with only his wife and daughter in attendance.

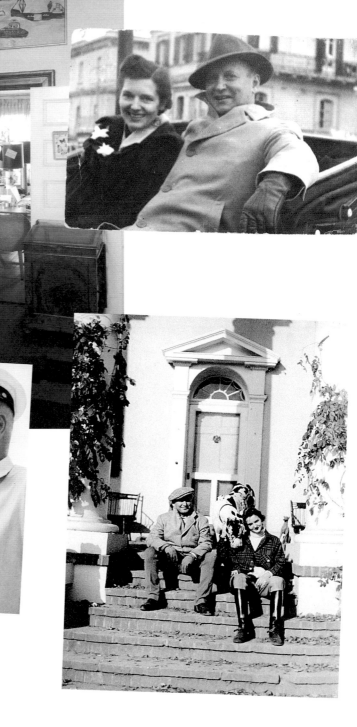

Clockwise from top right: Bemelmans with Mimi in Rome; Bemelmans with Barbara in Virginia; Sailing in the Caribbean; Aboard his boat, the Arch de Noe; Painting in Europe; Bemelmans' last apartment, in Gramercy Park.

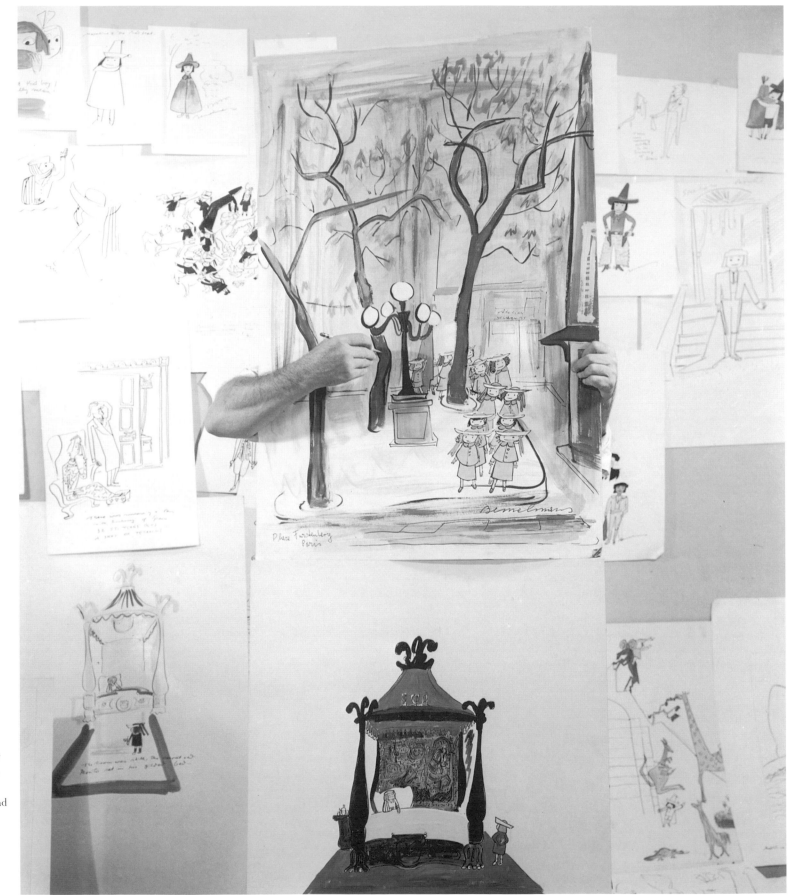

Bemelmans at work on Madeline and the Bad Hat.

Part IV
The Making of a Madeline Book

"We are writing for Children but not for Idiots."

—From an editorial note to May Massee

Jan . 13 61

MADELINE IN LONDON :

 After thinking some three years in images on this
book , looking at London , sketching London , going through books
photographs ,doing at least a thousand sketches , now that the time
of execution has arrived , almost all that was preconceived has to
be discarded and a whole new system of visual presentation invented
on account of something that did not come out of hiding until now .
 THE USE THAT HAS BEEN MADE OF THIS MATERIAL IN ADVER_-
TISING , FOR EXAMPLE A WHOLE PAGE DONE OF THE SCOTCH GUARDS , IS
OUT , FOR IT LOOKS LIKE AN AD FOR DEWARS SCOTCH WHISKEY - .
 It has occured to me , while looking at the mountain
of material , that a very good and useful and gay book could be made
under the title of : THE MAKING OF A CHILDRENS BOOK , in which these
birthpangs and agonies and pressures are detailed , for example the
3oo watercolors made so far for Madeline in London could be reduced
to
minuscule illustrations .
 Luckily I have swung myself back on the trapeze and
found a way out , and that is always , to go back and look at it
with fresh eyes ,so I have locked all the soldiers and parade stuff
that was ;away , and rearranged them in new formations and placed
them so , that they do not look like Whiskey ads , traveling posters
or ' Come Visit England ' throw aways .

 LB .

*The final page
of a letter to
May Massee.*

This section looks at how Bemelmans created a Madeline book. Although it is divided into stages, Bemelmans did not work in such an orderly fashion. He would let his imagination run forward, refine what he had done, then step back and begin again. He was never afraid to throw anything out, be it a plot twist or the plot itself. Also, Bemelmans did not divide himself into writer and illustrator—pictures and rhymes would be worked out together. A drawing could dictate the plot as easily as the other way around. No rhyme in the text or gesture in a picture went unconsidered. One of Bemelmans' great achievements is that, although he spent years on each Madeline book, nothing in these books seems at all labored. He worked hard at never losing the spontaneity of a quick sketch.

IDEAS THAT DIDN'T WORK . . .

Bemelmans was constantly coming up with ideas for books that he would put down on paper in the form of sketches and snippets of verse. Naturally, he never saw most of his ideas through, as he could do only so many books. Some ideas he worked on quite a bit before discarding, such as creating a Madeline version of his 1937 book *The Castle No. 9*.

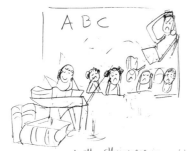

"Madeline & The Castle No. 9"

In an old house in Paris all covered with vines
Lived twelve little girls in two straight lines
The smartest one was Madeline.
No one was so quick
At problems in Arithmetic.
While the others were in anguish
Madeline just played with language.
Every medal and promotion did she earn
Until there was nothing more to learn.
One night she sat up in bed
"Girls," she said
"I'm widely read—
Over books I've pored and pored
and with knowledge I am bored—
I'm bored with every sort
Of dictionary word
In fact I'll be blamed
If everything [is] wrongly named
A cat—means nothing
And this object which is called a bed
Shall be known as a dreambox instead
Let's play a game
And give everything a name"

AND THE ONES THAT DID

Other ideas took root. They came from a variety of sources. Bemelmans claimed that he paid two girls fifty cents each for the idea for *Madeline's Rescue*. The plot, though, was often the least important thing. For instance, Bemelmans knew he wanted to send the girls to London, and his original idea was that they would accompany Miss Clavel home to England on a trip given to her by the school in return for her years of faithful service, but in the final version of *Madeline in London*, the girls go there to visit Pepito.

Bemelmans loved to travel. His trips provided him with many of his story ideas. In 1951 he went to northern Africa to write an article about Morocco, then a French colony. This trip apparently inspired a story idea, which he quickly summed up in a "To Do" note entitled "Madeline and the Arab." Bemelmans would later rename the story "Madeline's Christmas."

Bemelmans and his Studebaker at the entrance of Fez.

OUJDA _____ 400
ORAN _____ 618
ALGER _____ 1022
TUNIS _____ 1917
TRIPOLI _____ 2709
BENGHAZI _____ 3778
ALEXANDRIE _____ 4880

MADELINE AND THE ARAB

TO DO :
A Christmas story without Santa Claus
or the usual Christmas mise en
scene , perhaps without a Christmas
tree ,but have it full of that
spirit ,Come in come in whoever you
are –
 Madeline and the Arabian nights .
 In an old house in Paris that
was covered with snow freezing freezing
 lived twelve little girls,each
one of them sneezing ,
 The cook was in bed with the grippe
and Miss Clavel the teacher
ta ta ta ,
 Only the smallest one , Madeline
was up , and about and feeling fine –

IN SEARCH OF A CHARACTER

Bemelmans had great respect for children's powers of observation, and how quickly they could spot something that was false. Research provided him with the details needed to make his stories and pictures authentic. In *Madeline and the Bad Hat*, Bemelmans created the boy who would serve as Madeline's foil, Pepito. He conceived of the boy as an absolute horror, a torturer of animals, whose reform would be as spectacular as his cruelty; Spain—with its toreadors, conquistadors, Inquisition, and Civil War—made perfect sense as the boy's home country. The book was dedicated to Bemelmans' vegetarian wife, Mimi.

Painting in Spain, I found the model for Pepito in the third book—"Madeline and the Bad Hat." The boy's name was actually Pepito, he was the son of the Spanish Ambassador to France. He founded a society called La Sociedad Anti Gatino, of which several Spanish boys were members, and they hunted and shot cats around Paris for the pelts of which they got ten francs apiece from an Aunt who loved birds.

I wrote the story in Cordoba, and for three years I tried to get Pepito right, so that he would be a bad hat but worth loving and saving. I made several hundred sketches until I found him. I thought about my own childhood and being alone in the garden in Gmunden so I made him a solitary child. I also managed to get a guillotine into that book.

IN SEARCH OF A PLACE

In the south of France, Bemelmans found the perfect setting for a Madeline book: a Gypsy circus. He wrote:

> *This last summer, while painting around Paris I came to the fountains and basins of the Park in Marly le Roi. On the far side of it was a gypsy wagon and a merrygoround, a shooting gallery and swings, a little circus tent was to the right and a ferris wheel. The Gypsy children were playing, the boys splashing in the pool, two little girls who could not swim stood at the edge holding up their skirts. I painted it and there a new story began to form itself. I drove out to Marly le Roi, every day for some weeks, and followed the Gypsy caravan, the circus and merrygoround and I started on the new book, Madeline and the Gypsies. I have the story in mind more or less and some of the rhymes—now comes the great pleasure of finding gypsy faces, of deciding what cities in France the Gypsies will stop at, and painting them.*

While following the circus, Bemelmans documented what he saw in journals composed of anecdotes, descriptions, a verse or two as it came to him, and of course sketches. It was important to him that his book be as accurate a representation of Gypsy life as possible. Bemelmans' fascination with Gypsies persisted past *Madeline and the Gypsies*. Many of his most soulful canvases depicted the itinerant lifestyle that Gypsies led, which found them traveling through society but not being a part of it. Bemelmans felt great sympathy with this way of life.

OUTLINE

Once Bemelmans decided he had a story idea that was good, he would sit at his typewriter and make an outline, a process he would repeat as the work progressed. In early outlines he would tend to ramble, thinking as he typed, while in making later ones he was more focused, which resulted in shorter texts. An example of a later outline is the one of *Madeline in London* displayed here, which contains more or less the plot of the finished book. The lines "Madeline, Madeline where have you been—/ I went to London, to see the Queen—" first appeared in Bemelmans' two page story "Madeline at the Coronation" in 1953.

```
                    Madeline  in London .

     Pepitos father is the new Ambassador to  England

     Pepito has a birthday  and he asks that for his party  , MADELINE

     the little girls  and Miss Clavel  be invitet .They fly across to

     London . They wish to give Pepito a gift , and decide on a horse -

     horses are expensive - but Miss Clavel belongs to a society   which gives

     deserving horses away - and one does not have to pay  -only to promise

     that  the horse will be  well taken  care of -now we have the horse - and

     it is taken home ,  and the girls hide it in the  stable , and clean and wash

     it and tie a ribbon on it , to present it  as the birthday gift . Madeline

     will ride it -- , all is ready -- when they hear a trumpet , and so does

     Winston - who is a onetime  horse of the Colonel of the Horse Guards -

     and goodbye - with Madeline aboard he is off to join  once more

     -- to do his duty - and so they go  and  visit the horse guards , and

     then Buckingham Palace , and  then  the horse shows all of London

     to Madeline - and at long last , they come home --

          Madeline , Madeline where have you been -

          I went to London , to see the Queen -

          At last Pepito gets his horse -

          HAHAHAHAHAHAHAHAHAHAHAHAHAHAHAHAHAHAHAHAHAHAHAH
                                   THE
          Thank heavens says Clavel , it could have ended worse.
```

FIRST DRAFT

Bemelmans was first and foremost a visual thinker, and more important then telling the story in words was telling it in pictures. Instead of waiting until he had a working text to begin illustrating a book, Bemelmans would sit down and draw it.

His early efforts contained many wild ideas. For instance, in this first draft of *Madeline and the Gypsies*, Miss Clavel dresses up as a gypsy to save Madeline and winds up in jail with what seems to be a lion, but is really Madeline and Pepito stitched inside a lion's skin. Bemelmans reined in some of these wilder elements as he refined the story, but he kept as many of them as possible. So while Madeline and Pepito in the lion's skin appeared in the finished book, Miss Clavel dressed as a gypsy did not.

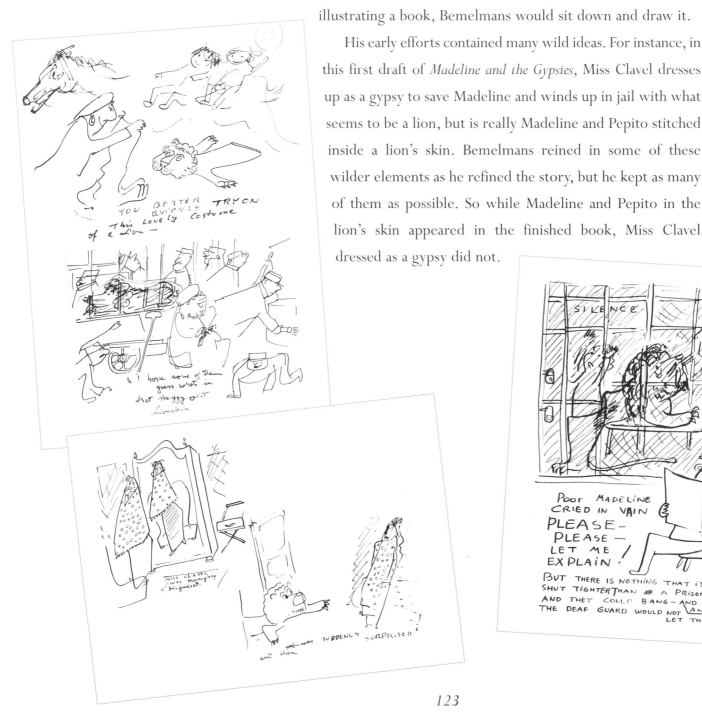

THE MAGAZINE VERSION

Bemelmans would read his stories to children, gauge their reactions and listen to their suggestions at every stage in the making of his books. But the first public test of a story came when he produced a version of it for a magazine. *McCall's, Good Housekeeping* and *Town & Country* were some of the places his children's books first appeared, often with titles that would eventually change. The magazine pieces would usually contain a book's worth of text along with a sampling of pictures.

How much the text and pictures changed from magazine to book varied. In the case of "Madeline and the Gypsies," which was published in *McCall's* in 1958 and as a book later that year, the text was merely tweaked, while nearly all of the pictures were redone. The layouts and gestures did not change much, but the look of the Gypsy characters as well the overall visual feel did. To suit the story, Bemelmans employed a more dramatic palette in this Madeline book than he had in the previous three.

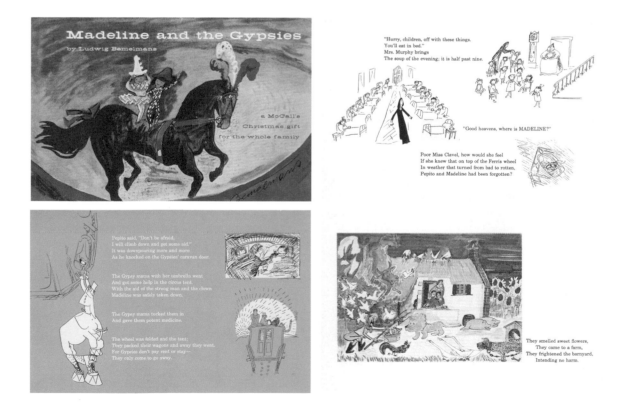

"Madeline's Christmas" was published in the December 1956 issue of *McCall's*. Bemelmans intended to make extensive changes to the tale before publishing it as a book. With a new working title of "Madeline and the Magician," he planned on expanding the drama considerably and putting more focus on the magician, Mustapha. Bemelmans began to ready the book for

publication in 1962 but died before getting very far. The *Madeline's Christmas* that exists today was published in 1985, based on the *McCall's* version. Because the location of the original artwork was unknown, an illustrator was hired to photographically enlarge the pictures from the article and recolor them.

THE DUMMY BOOK

Bemelmans always made several dummy versions of each book. A dummy book is a standard publishing tool. It is a mockup of a finished book with the same number of pages, and often the same size. The text appears in place, as do the illustrations, in the form of sketches or reproductions of the finished art. A dummy book allows one to see the pictures in relation to the text, how one page looks across from another, and how the story flows as the pages are turned. Bemelmans' dummy books helped him to rein in some of his wilder and more rambling ideas, and forced him to make the difficult decisions of what to cut.

Shown here is part of a dummy Bemelmans made for *Madeline's Rescue* composed of pencil and watercolor sketches. At this point, Bemelmans was relatively far along; he had roughly worked out the story and character of the book. But from the erasures and cross-outs, one can see that he was still adjusting the rhymes. While the composition of most of the drawings has been worked out, the one of Miss Clavel pleading to the trustees would be completely changed.

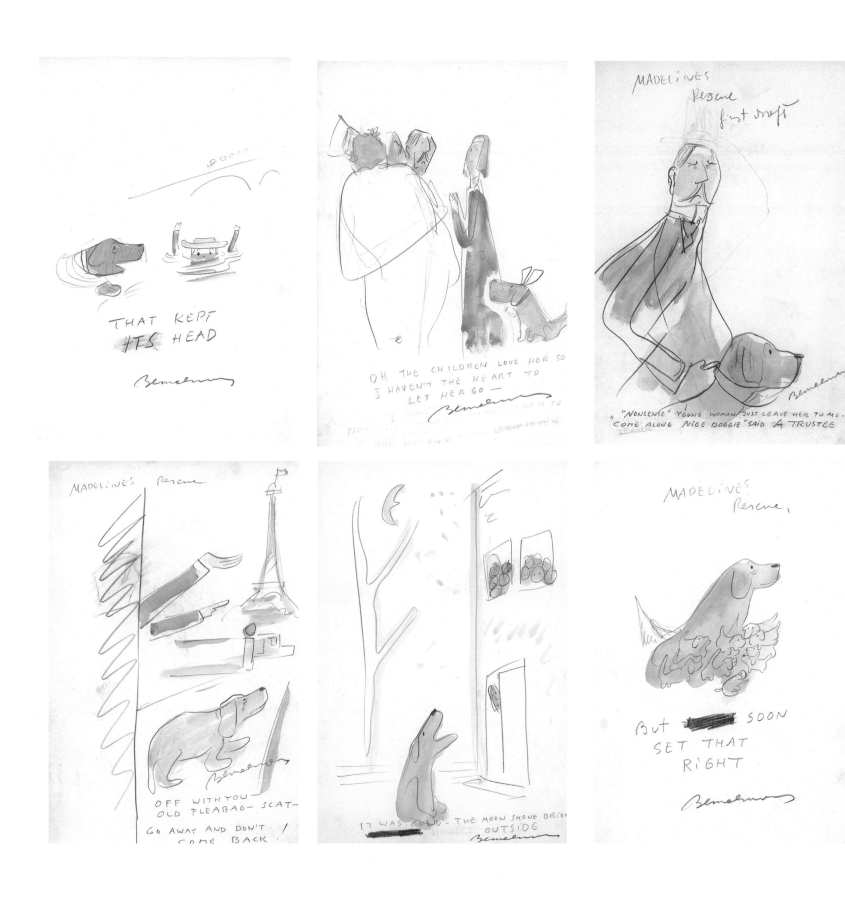

THAT KEPT
~~ITS~~ HEAD

OH, THE CHILDREN LOVE HER SO
I HAVEN'T THE HEART TO
LET HER GO—

MADELINES
Rescue
first draft

"NONSENSE" YOUNG WOMAN JUST LEAVE HER TO ME
COME ALONG NICE DOGGIE" SAID A TRUSTEE

MADELINES' Rescue

OFF WITH YOU
OLD FLEABAG- SCAT-
GO AWAY AND DON'T
COME BACK.

IT WAS COLD - THE MOON SHONE BRIGHT
HOWLED OUTSIDE

MADELINES'
Rescue.

BUT ~~——~~ SOON
SET THAT
RIGHT

127

On Children's Book Illustration

At last, Bemelmans would sit down and illustrate the book. Having worked out how every page was going to look through hundreds of sketches and paintings and several dummy books, he now began to execute the drawings—for him, an easy and agreeable task.

Although Bemelmans was careful not to vary the signature elements of a Madeline book too much, his approach to illustrating them evolved with each story. One reason for this was that he never stopped learning from children, about what appealed to them and how they saw the world. In 1955, Bemelmans was working on *Madeline and the Bad Hat*. He was also spending a lot of time with his two-year-old godson, Marc Antonio Crespi. In the following essay, Bemelmans explains how reading to Marc (photo at left) helped him to understand the importance of creating images a child could recognize. It appears here for the first time.

This is written in Gstaad, a small village in Switzerland, at an altitude of 1600 meters, and I find myself the house guest of a young couple from Rome, Count and Countess Crespi, and of their son, my godson, two years and three months old, who staggers about in the garden.

The Romans love ringing names. The baby's father is Marco Fabio and the little one is Marc Antonio. His mother is American and her name is Vivi.

The baby has a Swiss mademoiselle and just now he speaks or tries to speak French. He is at the stage where he says half of the word. Sieu stands for Monsieur. Core means encore, Peau means drapeau. Peep, which he invented himself from observation, is bird.

He has a **Babar** *book, and the elephant is* fant, *The little elephant is* bébéfant. *I brought him* **Madeline's Rescue,** *and I have observed him and learned a bit about making children's books that I ignored before I became the baby sitter at the chalet here.*

Marc looks at the jacket of the book and the sun in it is red and big. That means

nothing to him, for his sun is golden and smaller. The bridge and the Institute de France leave him cold. But on top of the Institute waves the French flag, and this he recognizes and says peau, which means drapeau. He recognizes this because the first of August was the national Swiss holiday and on every Swiss house, hotel and public building were lots of drapeaux. Then he studies the jacket and finally he says half of the word that stands for boat, which is teau, meaning bateau. He has seen ships below on Lake Leman, but the ship on the jacket of this book is only half a ship, being partly hidden by the bridge. Marc plants his finger on it and checks saying, "Teau? Teau?" and looks at me seriously worried. When I say, "Oui, bateau," he is happy. Then he discovers the dog to which he says wau wau. The little girls mean nothing to him. He hasn't seen them march in two lines nor seen a nurse like that. The nurses and mademoiselles in Switzerland are at this time all in white, and the trees have leaves on them so the bare trunks baffle him, for in the winter he was in Rome and there the trees are mostly pines and tropical. There is greenery the year round.

Now we open the book and come to the endpapers, and there is a familiar object, birds—to these he says peep peep. Then the school in which Madeline and the other little girls live—to this he says son, which means maison and all this is always given the stamp of approval by having his finger pressed down on the picture. So we go through the book, but there is much that is of no interest to him, and only the things he recognizes are of any consequence. This holds true of adult reading also: people have most pleasure out of things with which they can identify themselves.

Now every evening I have the books brought to me and I am sorry to say that Babar is more in demand by Marc Antonio than Madeline's Rescue. Of course he is only two years and three months old and in Rome he has seen a fant and a bébéfant in the Zoo, also many strange peep peeps.

This child could put us all in the hospital if we tried to do what he does all day long—immense promenades uphill, hours of play, and then the reading hour. I am quite exhausted with Babar and with my own book now, and always there is the same ritual—peau, teau, wau wau, peep peep—all the way to the end of the book as

if he had just discovered it. The lesson to me is important, and it will influence my designing of children's books.

The first responsibility of the artist is to be himself. Within these limits, however, he can play variations. Renoir has said, "Being a good craftsman never stood in the way of genius."

Since my lessons learned with Marc Antonio, I have revised a good many of the illustrations for the coming Madeline and the Bad Hat, *making them much more simple than I had them in mind. I discipline my illustrations as is, but they must be absolutely clear for children. A flower must be a flower, the sun must be the sun. It can be stylized, it can be the image of a thing, but it must be simple, clear, and at once understood. Since the objects in nature are the most beautiful, one must merely stick to the original with the child's eye in mind. He sees it as on the first day of creation, and so it must be.*

Madeline and the Bad Hat *has been in work for two years now. The Bad Hat is a bad boy, the son of the Spanish ambassador who moves next door to the school of the little girls, and they eventually reform him. Its theme is kindness to animals. The sketches so far made were for the Bad Hat. I wanted him really bad, but sensitive and reformable. He had to be as strong as the good boy as he was strong as the bad. I have him and he is satisfactory.*

The story will be set in the Bois de Boulogne. I intended to stylize these scenes a great deal. But with Marc Antonio in mind I will put real leaves on the trees, and the peep peeps *will be actual, carefully done birds, as will be all the animals, for that is most important.*

I have made some thousand sketches so far, but don't be impressed by that for I sketch with facility and speed. The drawing has to sit on paper as if you smacked a spoon of whipped cream on a plate—and did that with some practice so often that you'd get a shape you were after. I can't what is called "noodle" a thing, erase or do over and carefully compose. The picture is in the mind and the hand must project it on the paper exactly as it is in the mind. It has to be instantaneous, a flash, then it's good.

GETTING IT RIGHT—THE FINAL TOUCHES

As deadlines for publication neared, a flurry of correspondence would race back and forth between Bemelmans and his editor, May Massee. The focus of most of these letters was on the text, and it was at this point that politeness gave way to bluntness. The words and phrases Bemelmans had been pondering for years were about to be set in print forever, and the choices he made would be ones that he would have to live with and by which he would be remembered. The last complete book of the Madeline series, *Madeline in London*, caused Bemelmans the most grief. The time pressure on this book was particularly intense, and when he was done he said he would never rush anything again. The urgent correspondence that immediately preceded the publication of this book can be seen in the final set of editorial notes that Bemelmans sent Massee. The ones displayed here are a mere sampling, but give an idea of how, page-by-page, Bemelmans would decide a book was finished.

THE PUBLISHED BOOK

After years of work, thousands of sketches, hundreds of paintings, dozens of story ideas, outlines, and dummy books, Bemelmans would finally hold in his hand the finished book. It remained a curious thing for him, a thrill, but also by the time it was in bookstores, a thing of the past. Bemelmans kept copies of almost none of his books. When they came out, he was already working on another one, or more often three, and then there was painting and whatever else was holding his interest at the time. In the end, the books belong to the audience.

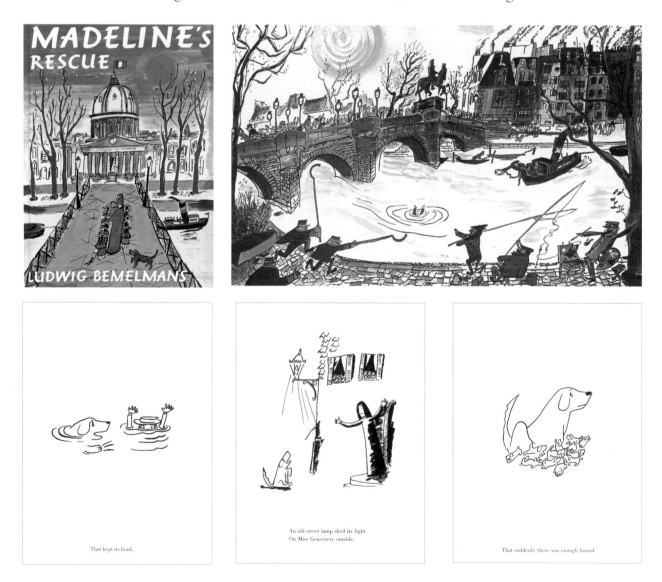

That kept its head.

An old street lamp shed its light
On Miss Genevieve outside.

That suddenly there was enough hound

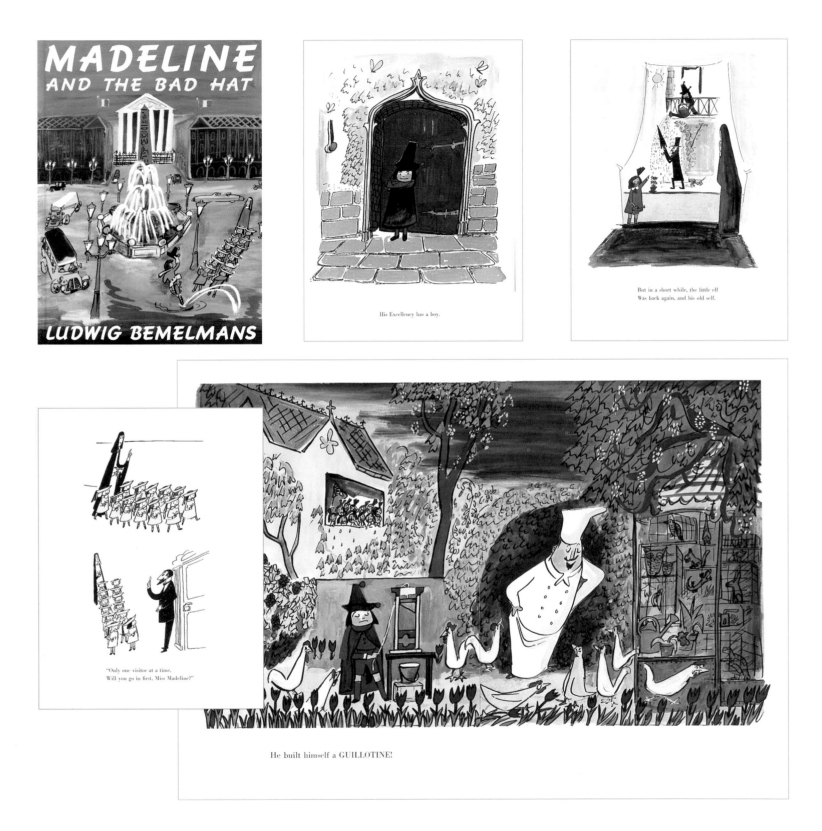

His Excellency has a boy.

But in a short while, the little elf
Was back again, and his old self.

"Only one visitor at a time,
Will you go in first, Miss Madeline?"

He built himself a GUILLOTINE!

The Gypsy Mama with her umbrella went
And got some help in the circus tent.
With the aid of the strong man and the clown,
Madeline was safely taken down.

"Look," said Madeline,
"There in the first row—"

"Oh yes," said Pepito,
"There are people we know!"

He frightened the barnyard— Intending no harm.

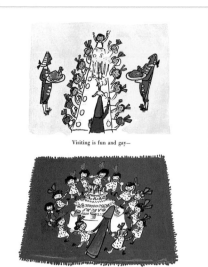

Visiting is fun and gay—

Let's celebrate a lovely day.

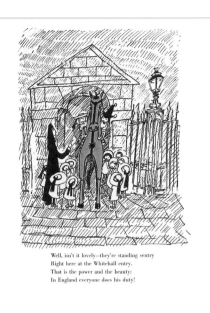

Well, isn't it lovely—they're standing sentry
Right here at the Whitehall entry.
That is the power and the beauty:
In England everyone does his duty!

"Madeline, Madeline, where have you been?"
"We've been to London to see the Queen."

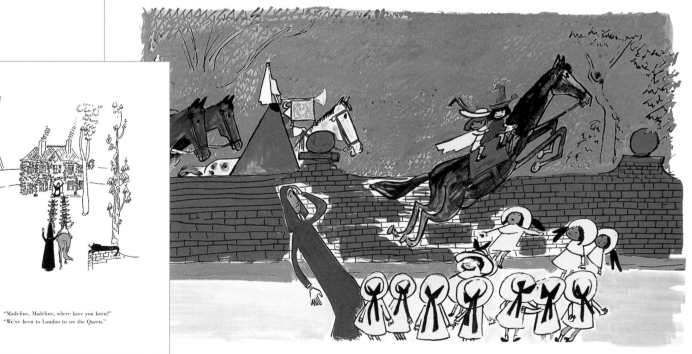

Just then—"Tara, tara"—a trumpet blew
Suddenly outside, and off he flew
Over the wall to take his place at the head

Of the Queen's Life Guards, which he had always led
Before the Royal Society for the Protection of Horses
Had retired him from Her Majesty's Forces.

Dear First Lady

While finishing up *Madeline in London*, Bemelmans was also working on a story with Mrs. Jacqueline Kennedy, who was the First Lady at the time. In her October 1962 condolence letter to Bemelmans' wife, Mrs. Kennedy wrote:

> *That is how I got to know him—One stormy autumn when I was alone in Hyannis*
> *with my daughter—and all we did was stay inside and read* Madeline—*I wrote him*
> *a letter saying how much they meant—and he sent me back a sketch of Madeline—*
> *inscribed "for Jacqueline's baby" which hangs in Caroline's room.*

From this they began a correspondence, through which they planned to do a children's book, possibly with Madeline visiting the White House. Unfortunately, the project never had the chance to be realized.

LUDWIG BEMELMANS

Dear first Lady

Yes we have to do it — but it will have to be the best of the lot.. For me Madeline is therapy in the dark hours when the black cosmic cloud sinks down — I make up the verses —

Much must happen that is amusing at the White House — I've been thinking of a white mouse — but there are millions of things — and the embarrass. de choix will be the biggest problem — Pictorially there is all that we need —

over —

The next Madeline is Madeline and the Magician which is finished in my head — so there is lots of time au revoir, bless you much love to you toujours

Vive Jackie!!

et MORT... ...

I am sending ...
I will alw...
and would ...
the wife of a ...
Captain and I ...
belle femme — tres ...
in your Madeline bu...
the Plane — I am leav...
of APRIL — AND to s...
A NEW SET OF GLAND...
so that I am going t...
with more ease — Lou...
and AU revoir

When I get back ...
on Madeline and Th...

NASSAU
19. II. 62

Dear Jackie

I've been doing fish for MARINA UNDER THE water SAW YOU TOUR OF THE WHITE HOUSE LAST NIGHT ON LAND. TRES BIEN — TRES BIEN — TRES BIEN VERY RIGHT. NO WRONG MOVE. FLYING BACK. N.Y. TOMORROW = Love

Ludwig

Merry Christmas to all from Miss Clavel.

Madeline visits Caroline

Problems : <u>A SIMPLE STORY</u>

The story . So far Gypsies , animals ,and the search for a horse have been used to carry the story .

A VISIT TO THE WHITE HOUSE , A VISIT TO WASHINGTON (as was done with Paris and London)

It is filled with possibilities the embarrassement is that of choice . .

There was an Idea of the White Mouse in the White House , who lived there because nobody could see it. , but the mouse could see everything with its crystal rose´ eyes (we would show only those eyes on a white ouline of the W.H.) There are all the possibilities that come from living in it .There can be the possibility of Miss Clavel getting lost and the children looking for her . There is the childrens party with children of all faces and races . Write it down . write it down , memory is very unreliable and draw it also cher colleague - Maybe it will suddenly form itself. Trust most to your instinct and to the subconscious mind - which keeps on working and puts things in order out of all that has happened since childhood .

I think it should be a book :
MADELINE VISITS CAROLYNE
Text by Jacqueline Kennedy
Illustrated by me ,

So please start rhyming ,
work on it a little while I'm gone
When we have a story , or when we have none
Then I'll get a place somewhere in Washington,a studio
to walk around , and start doing the pictures
and the story will float down , it always does ,
sometimes the very last minute .
The basic work on it we could do in the autumn . The thinking in Virginia . Liz (Who was Whitney and still iz , although she has married a ramrod and very nice man ,but I never can rememberthe names of them , yes Trippett - Colonel Trippet .Anyway Liz has always given me shelter at her violent estate ¨, and the dogs there used to like me very much .I always wanted to do a book about the Virginia country -and will never forget a Barbe que at which the great danes stood by in formation licking at the turning carcass of a beef side on the spit and jumping away at the heat of it .Anyway that is also an endroit where I can be working . I feel a lot better . You know what did it , the many injections they gave me for various diseases - goodbye .T H I N K
s.v.p. My only law in writing is that it must <u>amuse me</u> . Also remember that the start of these things is always terrible -the first draft awful in most cases . There is no such thing as inspiration free - from hard work , a fire builds and in the glow of that you sometimes find it and often not - adieu again ,

A page of a letter
Bemelmans sent to
Mrs. Kennedy in 1962.

138

Bemelmans

4/5/62

Hôtel Ritz
15 Place Vendôme
Paris

Hello
Jaqueline!
Are you
thinking?
About
the
story?
I am - Love
Ludovico le
Tête de Veau.

T. O. P.

Your mother told me
that you wrote
childrens books when
you were young — alas
young you always be —
when you were very
little — The more
I think of it — The
more I think it
should not be
Madeline — it
should be your own
and as I wrote
M. for my Barbara
so this should be
written for your own
children

Hôtel Ritz
15 Place Vendôme
Paris

Adios
again

UN grand merci pour le Madeline Caroline
Scenario cher
First Lady

We shudder and pray
for General de Gaulle for since he
exposes himself so recklessly and is
(one foot teller than all his compatriots
save Couve and a handfull of others) he
is an easy target. So let the bon Dieu
keep an alert ever present
Ange guardian over
him

Miss Clavel

P.T.O.

U.S.S. J.F.K

I Read the other day of
an AIRCRAFT CARRIER going to a trouble
spot to deliver 40 CASES OF BEER TO THE
LOCAL Y.M.C.A OR COMMISSARY OR U.S.
CONSULATE — THAT IS ENCHANTING INTELLIGENT
INSPIRED USE OF MIGHT

mes
homages

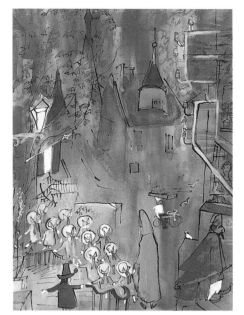

MADELINE AND THE MAGICIAN

Bemelmans died while reworking the *McCall's* version of "Madeline's Christmas" into "Madeline and the Magician." In addition to the magazine piece, he left behind fragments of pencil sketches, ink drawings, typewritten manuscripts, quickly scribbled notes, and small paintings that are tantalizing indications of where he was taking the story. Some of these pieces are put together on the following pages, and from them one can almost see "Madeline and the Magician" as Bemelmans imagined it.

The beginning of the story, which appears below, is the only part of the book for which Bemelmans had a working text. He planned to start this story differently from the other Madeline stories, which all begin, "In an old house in Paris…"

In Paris in this golden tower
Lived a magician of great power
If you have power, do not abuse it
For you certainly will lose it
And find yourself in an awful fix
No matter what your bag of tricks.
One day the magician's little dog
Made a spot on his favorite rug
The magician said ABRA CADABRA
And changed the dog into a bug
And after that he stepped on him
As he did the glow on his magic ring went dim.
The golden tower turned to lead—
The magician had no wine no bread—
He tried to sell his priceless rugs
But people turned him away with shrugs.

At the old house in Paris, Madeline is in charge because Miss Clavel is ill and bedridden. Someone knocks at the door—it is the magician Mustapha, selling his rugs. Madeline buys them all. Without his rugs or his magic, Mustapha almost freezes to death in a blizzard. He returns to the house, and Madeline nurses him back to health. While he is recovering, she goes out and brings back a Christmas tree, which Mustapha bends down to light.

As he lit the little Christmas tree, his magic ring began to glow
And the little tree stretched itself and started to grow.
Upon this good deed his power was back—

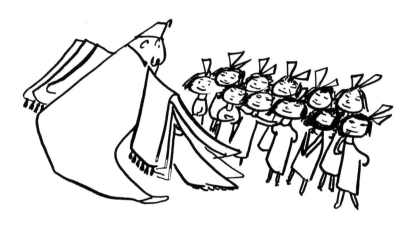

Mustapha is so grateful that he uses his restored powers to grant the girls their every desire. He takes them to the best beauty salons of Paris and to the Taj Mahal, and gives them all the answers to their schoolwork. Then he transforms the old house, adding "A lake with swans and a tree with Papayas / And mountain goats from the Himalayas." Mustapha tells them that now, "Everyone of you has a room with its own bath, / Television, and of course a thermostat."

The girls are caught up in all the excitement, but then they remember that Miss Clavel is very sick. "Oh—Miss Clavel/Please hurry and make her well." Mustapha is able to grant their wish and cure Miss Clavel with his magic, but when she comes to her senses and sees all that the magician has wrought, she is not happy. She tells him to undo all that he has done, and then leave. Suddenly, there is a great, blinding storm, and when it settles, all that is left of Mustapha is his fez.

The girls are terribly sad. While they are mourning Mustapha, Miss Clavel enters their room and says:

"Look little girls what I've just found—
A little lost kitten, crying and wandering around."
"Who really wants an old pussy cat—
We would all love our magician back."

The rest of the story is best told by Bemelmans himself. The drawing of Miss Clavel and the cat, only half complete, and the one on the next page are among the last pictures Bemelmans ever drew. He knew that he was gravely ill when he penned these drawings and their accompanying rhymes. This makes the final events of the book—the Magician's apparent death, his return, and his yearning to stay with the girls unnoticed—seem too fitting, too poetic to be mere chance.

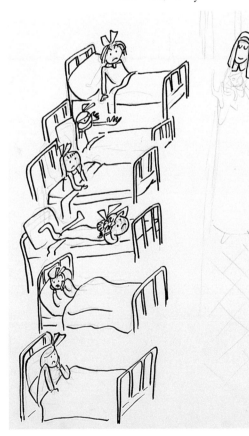

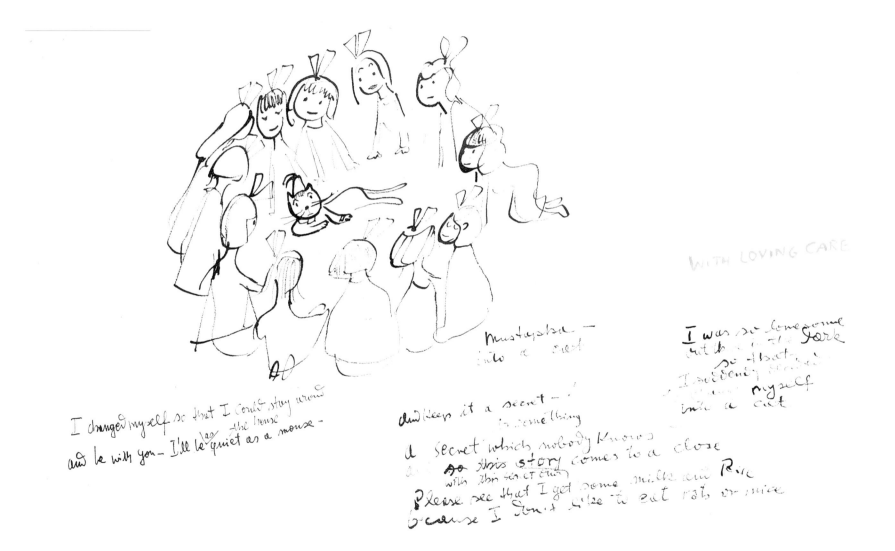

Mustapha —
into a cat

I was so lonesome
out in the dark
so that I
suddenly
myself
into a cat

I changed myself so that I could stay around
and be with you — I'll be quiet as a mouse —

And keep it a secret —
is something
A secret which nobody knows
so this story comes to a close
with this secret ending
Please see that I get some milk and Rice
because I don't like to eat rats or mice

WITH LOVING CARE

Chronology

1898 Ludwig Lampert Alfred Bemelmans born in Meran, Austria, to Lampert and Franciska Bemelmans on April 30

1904 Father abandons Ludwig and his mother, who move to Regensburg, Germany; Brother Oscar born on April 17

1914 Emigrates to the United States

1915 Goes to work at the Ritz-Carlton in New York City

1917 Joins the United States Army

1918 Becomes naturalized United States citizen; Honorably discharged from army

1926 Writes and illustrates *Thrilling Adventures of Count Bric a Brac* for the *New York World*

1931 Brother Oscar Bemelmans dies on August 5, age 27

1934 *Hansi*, Bemelmans' first work for children, is published; Marries Madeleine Freund

1936 Daughter Barbara is born on April 21; *The Golden Basket*, Bemelmans' second work for children, is published and receives a Newbery Honor Medal the following year

1937 Begins to write and illustrate articles for the *New Yorker*, *Vogue*, and *Town & Country*; *My War with the United States*, Bemelmans' first work for adults, is published

1939 *Madeline* is published and receives a Caldecott Honor Medal in 1940

1943 *Now I Lay Me Down to Sleep*, Bemelmans' first novel, is published

1953 *Madeline's Rescue* is published and goes on to receive the 1954 Caldecott Medal

1956 *Madeline and the Bad Hat* is published

1957 The first major exhibition of Bemelmans' paintings is held at the Galerie Durand-Ruel in Paris

1958 *Madeline and the Gypsies* is published

1959 The Museum of the City of New York mounts an exhibition of Bemelmans' paintings

1961 *Madeline in London* is published

1962 Bemelmans dies in his sleep in New York on October 1

Acknowledgments and Credits

I would like to thank all the people at Viking who made this happen: Regina Hayes, who saw how good this book could be; Cathy Hennessy, who saw the project through with tenacity; Stephanie Hutter, who kick-started it; Denise Cronin and Ed Miller, who made it happen visually.

A big thank you must be given to Caroline Kennedy for allowing us to reproduce the letters my grandfather sent to her mother, and to Megan Desnoyers at the JFK Library for making it so easy. Enormous thanks also to Eilleen Travell for photographing the works in my family's collection that appear in this book.

Murray Pomerance must be noted, and his *Ludwig Bemelmans: A Bibliography* consulted by anyone with a serious interest in Bemelmans. I looked at it daily in the writing of this book.

Thanks also to: Emily Chenoweth, for her insightful comments; Dan Fields, for years of supportive reading; Amy Fine Collins, for being the person who best appreciates this task; James and Paul, my brothers, for their support and faith.

Most of all, I have to thank my grandmother and mother. Words fail in describing what their support has meant to me; in terms of what they meant to this book, not only did they give me carte blanche in using all the materials they have in their possession, but it was their stories, dating back to before I can remember, that provided the shape of this book, and in the process of writing it, so many of the actual details.

Excerpts from *Madeline; Madeline's Rescue; Madeline and the Bad Hat; Madeline and the Gypsies;* and *Madeline in London.* Copyright © Ludwig Bemelmans, 1939, 1953, 1956, 1959, 1961. From *Tell Them It Was Wonderful: Selected Writings of Ludwig Bemelmans* edited by Madeleine Bemelmans. Copyright © Madeleine Bemelmans and Barbara Bemelmans, 1985. By permission of Viking, a member of Penguin Putnam Inc. • From *My War with the United States; Life Class; Father, Dear Father; To the One I Love the Best;* and *The Woman of My Life* (The Viking Press). Copyright © Ludwig Bemelmans, 1937, 1938, 1953, 1955, 1957. From introduction to *The Best of Times: An Account of Europe Revisited* (Simon & Schuster). Copyright Simon & Schuster, Inc., and Artists and Writers Guild, Inc., 1948. From *My Life in Art* (Harper & Row). Copyright © Ludwig Bemelmans, 1958. By permission of the Estate of Ludwig Bemelmans. • From *Fortune:* Two paintings ("Twin Cities"), issue of April 1936. Copyright 1936 by Time, Inc. By permission of the publisher. • From *Glamour:* Illustrations from "Postkarten aus Wien," issue of May 1937; illustration ("The only thing not antique in Bruges are these little girls"), September 1937; "The Island of Manhattan, as imagined by Ludwig Bemelmans," "War Relief Ball at the Ritz," and illustration from "Dance for Charity," February 1941. From *The New Yorker:* Cover art from issues of April 1, 1950; November 25, 1950; October 9, 1954; May 12, 1955; and October 3, 1959. From *Vogue:* Illustration from issue of September 1937 and photograph and illustrations from "Ludwig Bemelmans's Splendide Apartment," April 1942. Copyright 1937, 1941, 1942, 1950, 1954, © 1955, 1959 by Conde Nast Publications, Inc. By permission of the publisher. • From *The Saturday Evening Post:* Cartoon ("You May Tear It Down, Adolphe"), issue of December 16, 1936. Copyright 1936 by *The Saturday Evening Post.* By permission of the publisher. • From *Town & Country:* Two illustrations (one from "Buenas Dias, Gran Hotel"), issue of March 1940; cover art, June 1942 and February 1951; excerpts from "Adieu to the Old Ritz," December 1950; excerpt and two drawings from "La Casserole a la Bemelmans," January 1956; excerpts from "The Hotel Splendide—Revisited," April 1957; illustration and text from "Getting Fat—Getting Bald—" and illustration and excerpt from "A Gemütliche Christmas," December 1957. By permission of the publisher.

Sources

FOR CHILDREN

Bemelmans, Ludwig. *Hansi*. New York: Viking, 1934.

—— . *The Golden Basket*. New York: Viking, 1936.

—— . *The Castle No. 9*. New York: Viking, 1937.

—— . *Quito Express*. New York: Viking, 1938.

—— . *Madeline*. New York: Simon and Schuster, 1939.

—— . *Fifi*. New York: Simon and Schuster, 1940.

—— . *Rosebud*. New York: Random House, 1942.

—— . *Sunshine: A Story About the City of New York*. New York: Simon and Schuster, 1950.

—— . *The Happy Place*. Boston: Little, Brown, 1952.

—— . *Madeline's Rescue*. New York: Viking, 1953.

—— . *The High World*. New York: Harper and Brothers, 1954.

—— . *Parsley*. New York: Harper and Brothers, 1955.

—— . *Madeline and the Bad Hat*. New York: Viking, 1956.

—— . *Madeline and the Gypsies*. New York: Viking, 1958.

—— . *Welcome Home*. New York: Harper and Brothers, 1960.

—— . *Madeline in London*. New York: Viking, 1961.

—— . *Marina*. New York and Evanston: Harper & Row, 1962.

—— . *Madeline's Christmas*. New York: Viking, 1985. (The art for this book was photographically enlarged and recolored by Jody Wheeler).

Leaf, Munro, illustrations by Ludwig Bemelmans. *Noodle*. New York: Frederick A. Stokes, 1937.

FOR ADULTS

Bemelmans, Ludwig. *My War with the United States*. New York: 1937.

—— . *Life Class*. New York: Viking, 1938.

—— . *Small Beer*. New York: Viking, 1939.

—— . *The Donkey Inside*. New York: Viking, 1941.

—— . *Hotel Splendide*. New York: Viking, 1941.

—— . *I Love You, I Love You, I Love You*. New York: Viking, 1942.

—— . *Now I Lay Me Down to Sleep*. New York: Viking, 1943.

—— . *The Blue Danube*. New York: Viking, 1945.

—— . *Hotel Bemelmans*. New York: Viking, 1946.

—— . *Dirty Eddie*. New York: Viking, 1947.

—— . *The Best of Times: An Account of Europe Revisited*. New York: Simon and Schuster, 1948.

—— . *The Eye of God*. New York: Viking, 1949.

—— . *How to Travel Incognito*. Boston: Little Brown, 1952.

—— . *Father, Dear Father*. New York: Viking, 1953.

—— . *To the One I Love the Best*. New York: Viking, 1955.

—— . *The Woman of My Life*. New York: Viking, 1957.

—— . *My Life in Art*. New York: Harper and Brothers, 1958.

—— . *Are You Hungry, Are You Cold*. Cleveland and New York: World Publishing Company, 1960.

—— . *Italian Holiday*. Boston: Houghton Mifflin, 1961.

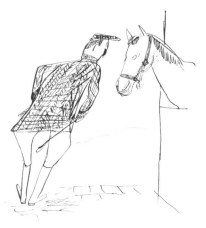

——. *On Board Noah's Ark*. New York: Viking, 1962.

——. *The Street Where the Heart Lies*. Cleveland and New York: World Publishing Company, 1963.

——. *La Bonne Table*. Selected and edited by Donald and Eleanor Friede. New York: Simon and Schuster, 1964.

——. *Tell Them It Was Wonderful*. Edited and with an introduction by Madeleine Bemelmans. New York: Viking, 1985.

SOURCES OF EXCERPTED MATERIAL (if not noted in the text)

Page 3, "I found myself in the arms of a strange woman, my mother . . . " is from "Swan Country," *Tell Them It Was Wonderful*, pp. 10–11.

Page 6, "She had become hard . . ." is from the unpublished story "In My Grandfather's Beergarden."

Page 13, "I shall forever be indebted . . . " is from "Hotel Splendide Revisited," *Town & Country*, April 7, 1957.

Page 14, "Theodore's most esteemed guest . . ." is also from "Revisited" but in part follows an unpublished draft entitled "The Hotel Splendide—revisited."

Page 16, "One of the backstairs family . . . " is from "Adieu to the Old Ritz," *Town & Country*, December 1950.

Page 18, "An esteemed guest . . . " is from "The Old Ritz," in *Tell Them It Was Wonderful*, p. 158.

Page 20, "One day I looked into . . ." is from "A Gemütliche Christmas," *Town & Country*, December 1957. It was later published in slightly altered form as "The Old Ritz," *Tell Them It Was Wonderful* pp. 158–59. In Bemelmans' manuscript entitled "Chapter 3/ Hotel Splendide," he doesn't give his age—this version has been followed because the two published piece give different ages, neither of which could be correct.

Page 24, "A typographer brought Miss Massee . . . " is from "May Massee: As Her Author-Illustrators See Her," *The Horn Book Magazine*, July-August 1936.

Page 77, "I had a picture of the harbor . . . " is from *My Life in Art*, p. 63.

Page 100, "The next evasion of the subject . . ." is from the exhibition catalogue *Bemelmans' New York*, published by the Museum of the City of New York, 1959.

Page 112, "The unchanged railroad station . . . " is from an unpublished manuscript, "The People of Regensburg," 1962.

Page 120, "Painting in Spain . . . " is from an unpublished manuscript, c.1956.

Page 121, "This last summer . . . " is a continuation of the above.

A NOTE ABOUT SOME OF THE ABOVE SOURCES

Tell Them It Was Wonderful was published in 1985 by Viking Press. It was edited by Bemelmans' widow, Mimi, and some of the chapters included material not previously published. One of them, "Swan Country," had appeared earlier in *My Life in Art* and was first published as "When You Lunch with the Emperor" in *Vogue* (September 1, 1958). For *Tell Them It Was Wonderful*, Mimi added an additional page of material from an unpublished story entitled "In My Grandfather's Beergarden," which is the text excerpted on pages 3–4 of this book. The other material from "In My Grandfather's Beergarden" appears here for the first time.

In 1957, Bemelmans published a trio of stories in *Town & Country*: "Hotel Splendide Revisited" (June); "Love at the Splendide" (August); and "A Gemütliche Christmas" (December). Bemelmans claimed to be setting the record straight in regard to his years at the Ritz-Carlton, which he had been writing about for twenty years as the fictional Hotel Splendide. In fact, it would be difficult to say whether these stories are closer to the truth—Bemelmans went through multiple drafts of each, and the "truths" conflict from one draft to the next. "The Old Ritz" in *Tell Them It Was Wonderful* was put together from these original manuscripts. All of these sources were taken into consideration in choosing which material to include in this book and how to handle it.

"Last Visit to Regensburg," the final chapter of *Tell Them It Was Wonderful*, comes from Bemelmans' unfinished novel *The People of Regensburg*. The excerpt on page 112 of this book is from the same source, but the editing choices are different ones, which accounts for the differences in the material.

Index

"Good night little girls
thank the Lord, you are well -
and now go to sleep"
said Miss Clavell -

and she turned out the light
and closed the door -
and that's all there is -
there isn't any more -

FINIS